D1531498

The Campus History Series

WELLESLEY COLLEGE

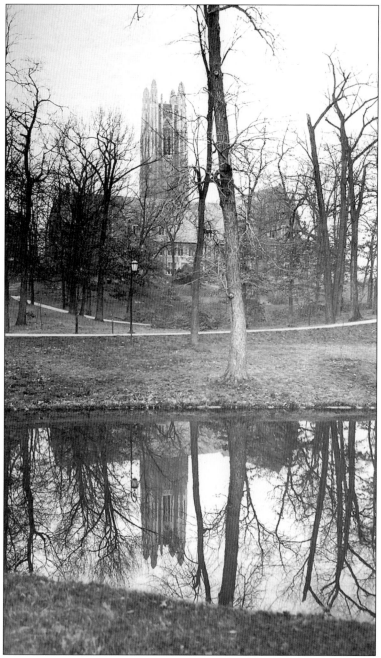

Three iconic images of Wellesley College are captured beautifully in this picture taken by photographer Clifton Church around 1936. Galen Stone Tower, Founders, and a solitary lamppost are reflected perfectly in Longfellow Pond, a small body of water that graced the lawn next to the library for nearly a century. (With the 1974 library addition, the pond was reconfigured into a concrete basin.)

On the cover: Seen here are Green Hall and Galen Stone Tower. (Courtesy of Wellesley College Archives.)

The Campus History Series

WELLESLEY COLLEGE

ARLENE COHEN

ARCADIA
PUBLISHING

Published by Arcadia Publishing
Charleston SC, Chicago IL, Portsmouth NH, San Francisco CA

Printed in the United States of America

Library of Congress Catalog Card Number: 2005937494

For all general information contact Arcadia Publishing at:
Telephone 843-853-2070
Fax 843-853-0044
E-mail sales@arcadiapublishing.com
For customer service and orders:
Toll-Free 1-888-313-2665

Visit us on the Internet at http://www.arcadiapublishing.com

This book is dedicated to Pamela Daniels.

CONTENTS

ACKNOWLEDGMENTS

In the sometimes overwhelming task of compiling a pictorial history, it is the assistance, guidance, and encouragement of others that brings the project to completion. I endeavor here to thank all of them, and it is my fervent hope that I have not left anyone out.

First and foremost, I must extend my gratitude to Wilma Slaight, Wellesley College archivist, and assistant archivists Jean Berry and Ian Graham. I want to thank them for their generous assistance in my research, their answers to my numerous questions, and the use of the abundant resources in the archives. Nearly all of the pictures in this book are courtesy of the Wellesley College Archives, and I am deeply grateful for their permission to use them.

I also want to express my gratitude to Mary Ann Hill, Wellesley's director of public information and government relations, for her support of my project and for some of the most recent photographs.

I thank Kathy and John Heckscher for providing me a home while I did my research at Wellesley.

Erin Stone, my editor at Arcadia, has answered my many, many questions with a great deal of patience, and I am very appreciative of her supportive guidance.

I thank my family—Mom, Dad, Mindy, Rebecca, Rick, and Shane—for their love and support. I particularly want to thank my parents for providing me the opportunity to attend Wellesley College.

My Wellesley friends remain dear to me to this day; because of them, my love for Wellesley emerged while in college, grew over the years, and eventually has led to the creation of this book. Most especially, I want to thank Sally Grant for her steadfast support and enduring friendship.

I am indebted to the chroniclers of Wellesley's history who have come before me and whose works I used as constant reference sources.

Finally, my deepest gratitude goes to Pamela Daniels, alumna from the class of 1959 and dean to six classes of students during her career at Wellesley College. She was my dean during my years at Wellesley and has been my friend ever since. Her love and support are immeasurable, and I could not have written this book without her profound wisdom, careful editorial eye, and gentle guidance at every stage.

INTRODUCTION

If it were possible to fly over Wellesley College in its early years, in the late 1870s or early 1880s, what would one see? A single grand building called College Hall stands five stories tall and stretches out nearly an eighth of a mile on a hill overlooking the lake. A very few small outbuildings and the roadways connecting them are but specks on the landscape. A class might be meeting on the benches outside the north doors of College Hall with an engaging professor guiding her students through a text or discussion. A boat or two might be skimming across a clear blue Lake Waban. Small groups of students might be out enjoying the day and the idyllic beauty of their campus, walking the paths, playing tennis on the lawns, or sitting deep in conversation by the lake.

Take a similar flight today and what would one see? A landscape changed, for College Hall, once the centerpiece of Wellesley, is no longer. Instead, numerous buildings define the campus—a library, a chapel, academic and administrative buildings, residence halls, sports facilities, and campus center. Together they serve the many purposes that were once combined in that original grand building. One still finds professors and their classes meeting outside on a beautiful day. Students still stroll, or hurry, along the paths, engage in sports, and linger in those long, deep conversations. And yet, of course, today's students are different—in background, in aspiration, in opportunity—from those first brave young women who came to Wellesley College in 1875.

Wellesley's founders, Henry and Pauline Durant, believed in the higher education of women and gave their land and their fortune to that cause. They built College Hall to be the entire Wellesley—classrooms, laboratories, library, chapel, and living quarters for students and faculty. At the same time, they knew that, over time, their college would surpass their original vision. And so it has. Substantial increases in student enrollment and in the physical plant are the tangible, visible evidence of this. Yet the heart of the enterprise, the education of young women in the liberal arts tradition, has held steady in a context of dramatic change and growth. And beyond the campus, Wellesley's alumnae, numbering in the tens of thousands around the world, stay connected to their alma mater and its ideals in many ways, not the least of which are the myriad manifestations in their lives of Wellesley's motto, *Non Ministrari sed Ministrare* ("Not to be ministered unto, but to minister").

In 1950, on the occasion of its 75th anniversary, the college produced a special edition of the *Wellesley Alumnae Magazine*, in which Wellesley's president Margaret Clapp wrote in the introduction:

It is natural that a Wellesley alumna, busy with the complexity of everyday living, should think of the college largely in terms of her own day. Somehow, the college sprang forth and was here to welcome her as a freshman. She vividly remembers the next four years; then her picture of Wellesley may become sketchy. She may not have had time, either as an undergraduate or since graduating, to make even a cursory study of Wellesley's heritage, to be acquainted with its founders and with the long line of men and women whose intellectual devotion has kept Wellesley in the vanguard of liberal arts colleges.

These words, written over 50 years ago, were part of the inspiration for this book.

This pictorial history of Wellesley College is one glimpse into its past. Nearly all of the photographs come from the Wellesley College Archives, whose holdings contain thousands of stories of which this book offers just a few. What stories to tell here? Which photographs to choose? How to arrange them? How to convey the boldness of the Durants' vision and the experience of this pioneering world of women's education? How to show Wellesley's evolution over the last 130 years? These have been the challenging, guiding questions.

My desire and hope in this work has been to renew the collective Wellesley memory with this treasure trove of images and, at the same time, to invite others to reflect on the metamorphosis of the college over the years. A few years ago, in a speech about enhancing the sense of coherence, meaning, and purpose in academic life, Wellesley's president, Diana Chapman Walsh, quoted a line from a Unitarian-Universalist prayer that poignantly sums up the hope of this book:

"Come into this place of memory and let its history warm your soul."

One

COLLEGE HALL AND THE
EARLY YEARS

The story of Wellesley College begins with Henry and Pauline Durant. After the tragic death of their son in 1863, the couple turned to their Christian ideals for solace and healing. They abandoned their plans to build a great estate for their son on their land outside of Boston and began pondering possible uses for those nearly 300 acres.

The decision to found a college for women was influenced by the Durants' active involvement with Mount Holyoke College, founded in 1837; Henry was a trustee, and Pauline had helped found the library there. Both believed strongly in the education of women and began dreaming of another great college dedicated to that purpose. They reached their decision in 1867 and called their new school Wellesley—the name of the neighboring estate owned by Horatio Hollis Hunnewell, whose wife's family name was Welles.

In 1870, the Massachusetts legislature incorporated Wellesley Female Seminary, and in August 1871, the foundation stone of College Hall, the grand building that would be the entire college in its beginning years, was laid. While the building was under construction on the hill overlooking Lake Waban, the planning of the college went on in earnest. In 1873, the Durants and their fellow trustees proposed a significant name change to the legislature; the new school would be Wellesley College.

Great care and attention to detail were put into the design of College Hall. Throughout the building, students were exposed to beauty, in the fine furniture in student rooms, the china plates on dining hall tables, the paintings on the walls. The Durants spared no expense. At the same time, they envisioned a Wellesley College for all who were capable. Tuition and costs were kept low so that Wellesley could educate (in Henry Durant's words) the "calico girls" as well as the "velvet girls."

When the college opened on September 8, 1875, a total of 314 young women arrived on the campus. Entrance exams showed that only 30 of these young women were ready to do college-level work, and they were enrolled as Wellesley's first freshman class; the others began college preparatory studies with the hope of attaining collegiate status within a year or two.

The Durants' dream was realized, and Wellesley College began.

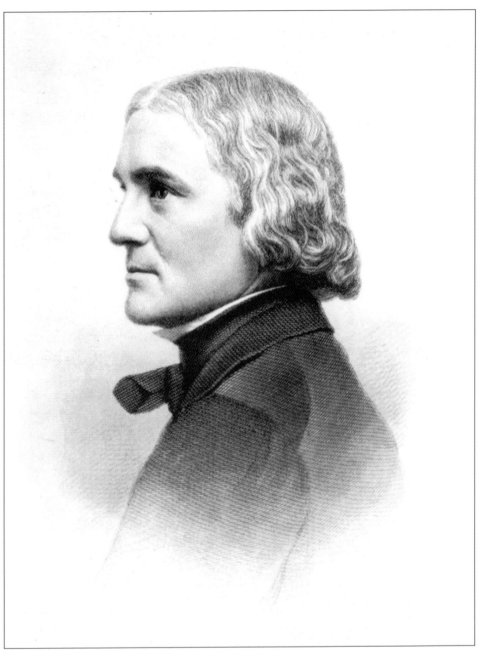

The founder of Wellesley College was born Henry Welles Smith on February 20, 1822. After graduating from Harvard, he began practicing law, first in Lowell, Massachusetts, and then in Boston. When he moved to Boston in 1847 and found many other lawyers there named Smith, he changed his name to Henry Fowle Durant, adopting two family names. He married his cousin Pauline in 1854 and began to amass a considerable fortune through his law practice and financial investments. In addition to their homes in Boston and New York City, the Durants purchased property in what was then West Needham, 12 miles outside the city of Boston, where they spent summers at their original farm. A part of the farm cottage remains on the land; it is a small residence hall called Homestead.

Pauline Durant is seen here in her wedding bonnet. She and Henry had two children—a son, Harry, born in 1855, and a daughter, Pauline, born a year later. The little girl died when she was only 12 weeks old, and the Durants doted on their surviving child, imagining a great future for him.

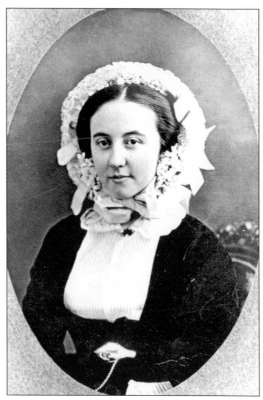

Tragically, Harry Durant succumbed to diphtheria and died when he was eight years old. His distraught parents felt the need to put their West Needham land, which would have been their son's estate, to good use. They considered an orphanage for boys, but eventually their convictions about the importance of the education of women took hold and the idea of Wellesley College was born.

11

On March 17, 1870, the Commonwealth of Massachusetts granted a charter to Wellesley Female Seminary. Three years later, another act of the legislature changed the name to Wellesley College. In 1877, a third act gave the college the right to grant degrees. The original charter hung on the wall outside the dining room of College Hall.

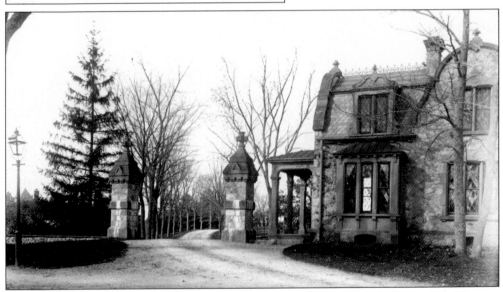

For many years, the entrance to Wellesley College was here at East Lodge on Washington Street. Through these stone pillars, carriages (and later automobiles) brought students and guests to College Hall. In 1912, a student wrote these words: "Through these gates each morn I wander, on my way to College Hall – And I shiver as I think on all the work not done at all."

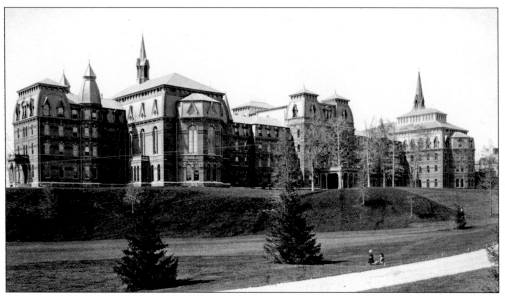

Traveling along the winding paths, one would eventually see the stately building called College Hall. In 1875, when the school opened, it was the entire Wellesley College: classrooms, laboratories, chapel, library, dining room, and home for all students and faculty. Five stories tall, it extended for nearly an eighth of a mile on a hill, overlooking Lake Waban to the south.

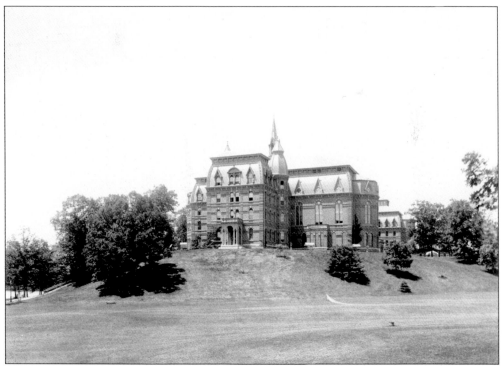

The open green and hillside at the east end of College Hall became the setting for outdoor gatherings, festivals, and sporting activities. Lake Waban is just visible on the far left. The large oak tree on the left side of the hill still stands today.

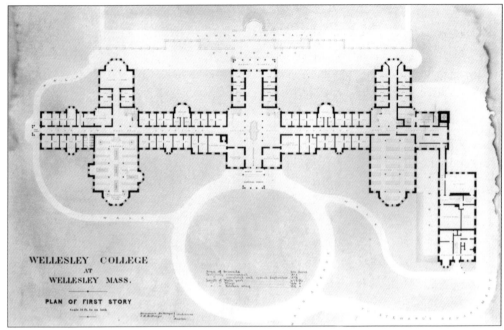

WELLESLEY COLLEGE
AT
WELLESLEY MASS.

PLAN OF FIRST STORY

This plan of the first floor of College Hall gives a sense of the comprehensive sweep of the building, with the library on the left, dining hall on the right, and numerous classrooms and residence spaces throughout. Designed by Hammatt Billings of Boston in the form of a double cross, its architecture expressed the Christian ideals upon which the college was founded.

The kitchen wing was at the west end of College Hall. A fire wall was installed between the kitchen and the main building on the theory that if fire broke out, it would be in the kitchen and the rest of the building would be saved. Ironically, the opposite turned out to be true, and the kitchen remnant of College Hall saw constant use until it was finally torn down in 1962.

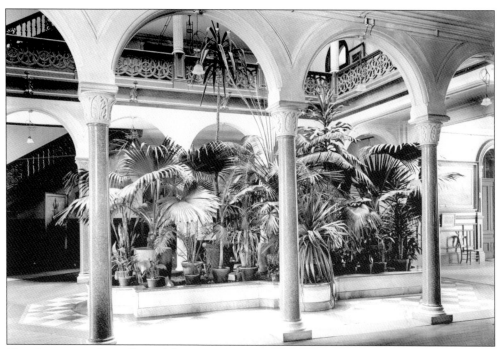

The Center was literally and figuratively the heart of College Hall. Here, in the atrium that extended up the full five stories, students would stop to chat, meet guests, or gather on their respective floors to hear announcements. Potted palms in a marble basin gave light and cheer to that special space. Works of art, including sculptures, drawings, and paintings, were found throughout the building.

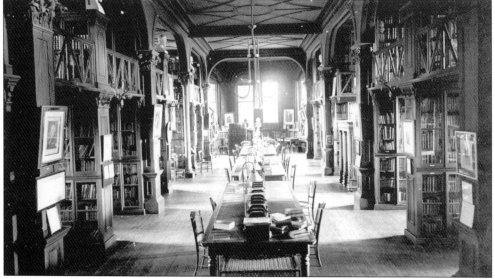

The Durants filled the library of College Hall with nearly 10,000 volumes from their personal library, including many rare editions. Students read and studied at the center tables, in the small room off to one side, or in the upper alcoves, reached by means of winding stairs. When a new, separate library building was built in 1910, this space became a study hall.

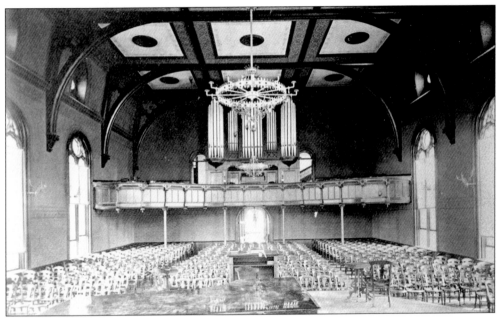

The chapel of College Hall was the site of daily chapel talks and weekly Sunday services, of welcome for distinguished guests, and of weddings and funerals among the early college community. When Houghton Memorial Chapel was built in 1899, this space became an assembly hall.

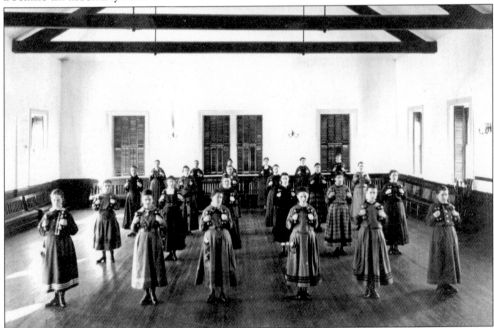

Henry Durant believed strongly in physical exercise for women, a radical notion in the later part of the 19th century. He outfitted the College Hall gymnasium with dumbbells, chest weights, and flying rings. Lucille Eaton Hill joined the faculty from Harvard in 1882 as a physical education instructor and, for the next 27 years, brought her enthusiasm for physical sport to the entire college community.

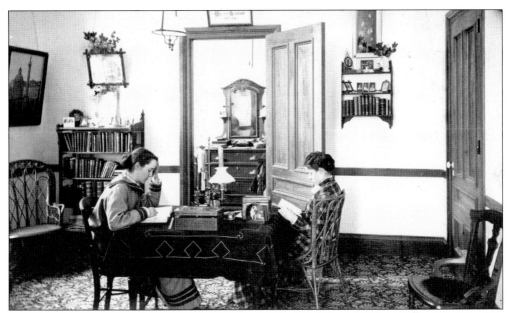

Most student rooms in College Hall were two-room suites, each made up of a bedroom and a study. A close look at these pictures of student rooms shows many of the details that make a dorm room a home. Surrounding the serious students and their books are pictures, flowers, and other decorations.

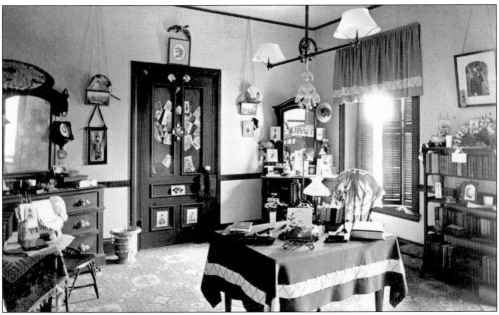

On the back of this photograph are these words: "Room 111 third floor west end Wellesley College June 1881. The scene of action – of various kinds – of four frisky, frolicsome females during the happy months . . . 'There's a new foot on the floor, my friend. And a new face at the door, my friend. A new face at the door.'" One of the four was Edith Tufts (class of 1884), who later became the college's dean of residence.

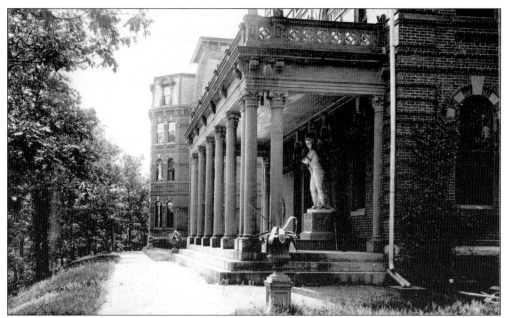

The south porch of College Hall facing Lake Waban was the home of the *Backwoodsman*, the large marble statue of a man with a raised ax seen near the center of this photograph. Over time, his appearance deteriorated due to the vigorous cleaning students administered each May Day. He mysteriously disappeared in 1912 and was mourned by the students.

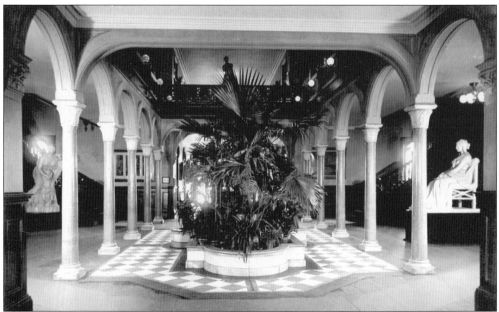

Beloved statues were found throughout College Hall, including *Niobe*, a tragic figure from Greek mythology, on the left and *Harriet Martineau*, a 19th-century English writer and social reformer, on the right in this photograph of the Center. A student rite of passage in Wellesley's earliest years was to put each freshman "through Harriet" by pulling her between the pedestal and the rungs of the chair.

The Japanese bell, shown here in place on the Center's second floor, came from an ancient Buddhist temple. The bell signaled the beginning and the end of classes, meals, and chapel gatherings—the significant moments of daily life. The bell's inscription read, "to awaken from earthly illusions and reveal the benighted ignorance of this world."

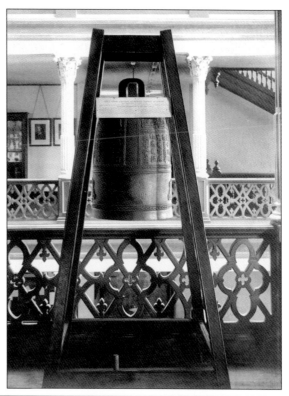

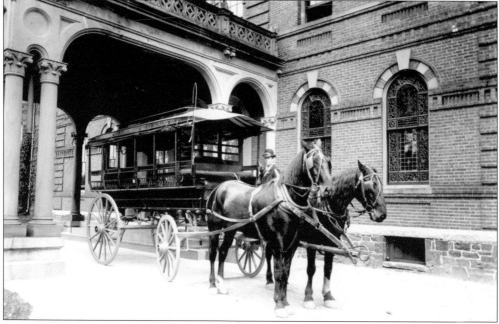

The Barge, with its driver Tom Griffin, was a mainstay in Wellesley's early years, conveying students and guests back and forth between the town train station and the college. Griffin worked at Wellesley for over 50 years, driving the Barge from 1886 until the advent of the automobile, when he became a taxi driver on the same familiar route.

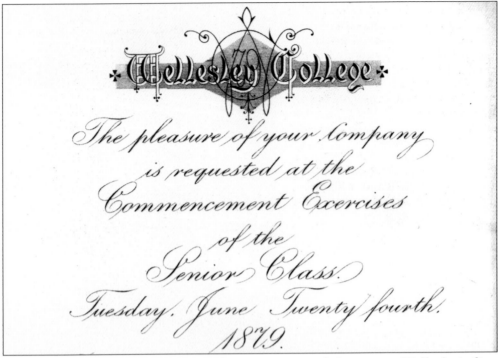

Wellesley College

The pleasure of your Company is requested at the Commencement Exercises of the Senior Class. Tuesday, June Twenty fourth. 1879.

Eighteen determined and dedicated women received degrees at Wellesley's first commencement in 1879. Rev. Richard Storrs of Brooklyn delivered an address on "The Influence of Women in the Future," noting that Wellesley was built for the purpose of carrying women forward from one stage of development to another. As quoted in a newspaper of the day, "[Wellesley's] purpose was as grand and beautiful as itself."

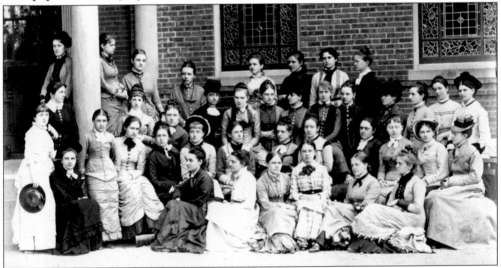

Wellesley's early graduates, such as these 40 women in the class of 1880, were pioneers in the field of women's education. Among this class were three who became preeminent professors at Wellesley: Charlotte Fitch Roberts, professor of chemistry for 36 years; Ellen Burrell, professor of mathematics for 30 years; and Katharine Lee Bates, in glasses seated fourth from right in the second row, professor of English for 39 years.

An important role model for Wellesley's early students was Dr. Emilie Jones Barker, pictured here in 1879. Adamant about having a female physician for his students, Henry Durant hired her in 1875, when she was still a medical student. She was determined to complete her medical degree and left the college, with Durant's blessing, for a short period two years later. Medical degree in hand, Dr. Barker returned to Wellesley in 1878 and, with one brief exception, stayed on until 1909.

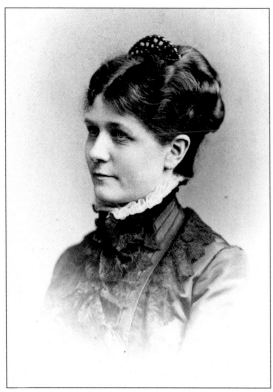

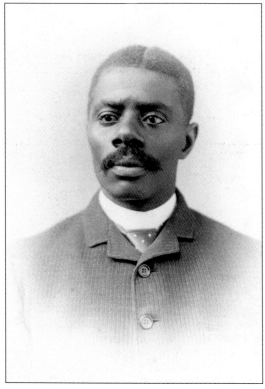

A member of the early college staff was Dominick Duckett. Though there is scant biographical information about him in the college's archives, his name is frequently mentioned in reminiscences of alumnae of the period. His duties included working in the kitchen and as a general handyman, but he is most affectionately remembered for his entertaining guitar playing, for selling fruit at a small stand in the Center, and for teaching students how to ride bicycles.

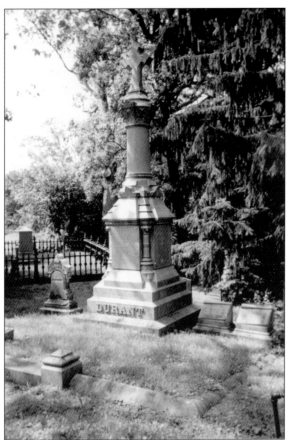

On October 3, 1881, Henry Durant died of Bright's disease in his bedroom in sight of College Hall, with his wife and Dr. Emilie Jones Barker at his bedside. The entire college went into mourning. His funeral was held in the chapel of College Hall, and he was buried in this family plot in Mount Auburn Cemetery in Cambridge, Massachusetts, where his mother, two children, and, later, his wife were all buried.

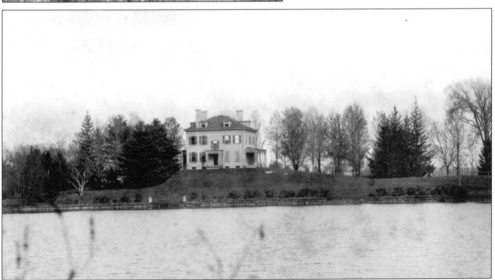

The Durants moved into this home on a cove of Lake Waban in 1865, a few years after the death of their son. After Henry Durant's death, Pauline Durant stayed on until her own death in 1917. The house then served as a guesthouse for the college until 1925, when it was converted into the President's House, its function to this day.

Harvard professor Eben Horsford was a close personal friend of the Durants. Like them, he believed deeply in the "experiment" of educating women. Horsford's many gifts to Wellesley ranged from the large and enduring (the endowment of the library in 1878) to the small and immediate (flowers for each member of the class of 1886). His generosity and leadership, both moral and financial, were especially important during the 12 years between Henry Durant's death and his own in 1893.

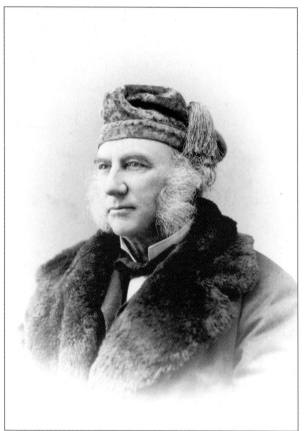

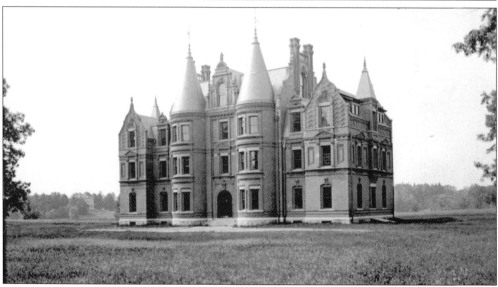

Henry Durant witnessed the beginning of Wellesley's growth before he died. In 1880, Music Hall (still standing today) was built, with Billings Hall added at the rear some 24 years later as an auditorium. When Music Hall was made available to student organizations in the 1960s, the entire building was renamed Billings.

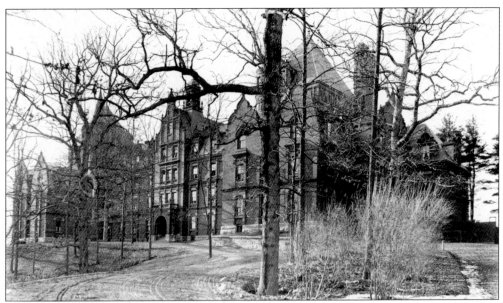

Also built in 1880 was Stone Hall, a dormitory overlooking Lake Waban. It originally housed the "teacher specials," secondary school teachers who came to Wellesley to become better qualified in their fields, and later became a dormitory for undergraduates. The building was scheduled for renovation and nearly empty when it was destroyed by fire on March 7, 1927. The charred remains were torn down, and the twin dormitories of Stone and Davis were built on the same site.

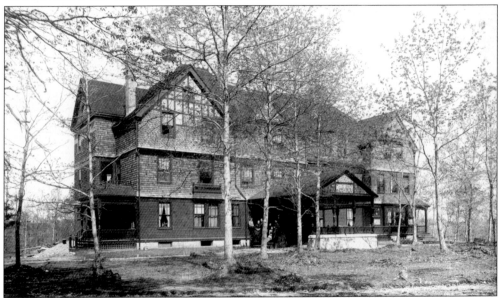

In the 1880s, Wellesley began building cottages on campus, allowing for smaller, more homelike living situations for students. Norumbega, pictured here, was among the first, built in 1887, and contained the president's suite. Three other small residence halls—Freeman (1888), Wood (1889), and Wilder (1900)—eventually joined it on what was then called Norumbega Hill. All were later taken down, and the hill became the Academic Quad.

Farnsworth Art Building was built on Norumbega Hill in 1889. It housed the Art Department and an art museum until 1958, when it was replaced by Jewett Arts Center. Five of the large circular stone medallions seen here on the upper part of the outside wall were saved. The names of the original buildings on Norumbega Hill were carved into them, and they were then placed in the Academic Quad, approximately where Farnsworth once stood.

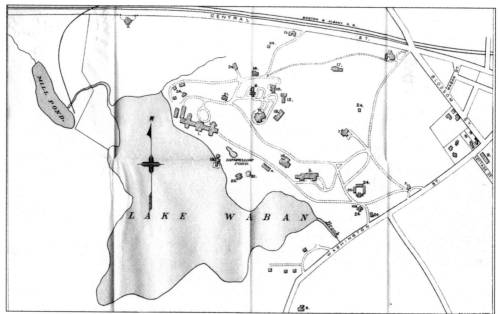

This 1899 map shows College Hall still prominent as the main building on Wellesley's campus; the number of other smaller buildings demonstrates the college's vigorous growth in its first 25 years.

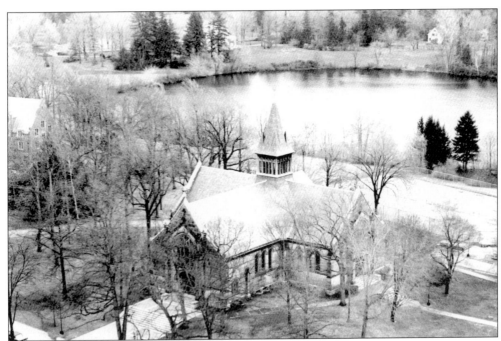

By the mid-1890s, Wellesley had outgrown its chapel in College Hall, and plans were drawn up for a separate building. After some debate about the location, the area between Stone Hall and Music Hall was chosen. When completed in 1899, Houghton Memorial Chapel could hold the entire college community, which it did at Caroline Hazard's inauguration as Wellesley's president that year.

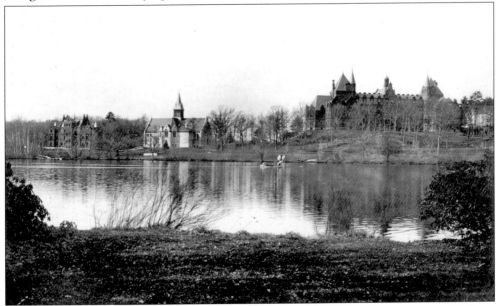

In this image, Music Hall, Houghton Memorial Chapel, and Stone Hall are seen from left to right from the cove of Lake Waban near the Durants' home. The photograph was taken sometime between 1899 (when the Chapel was built) and 1904 (when Billings was added to Music Hall).

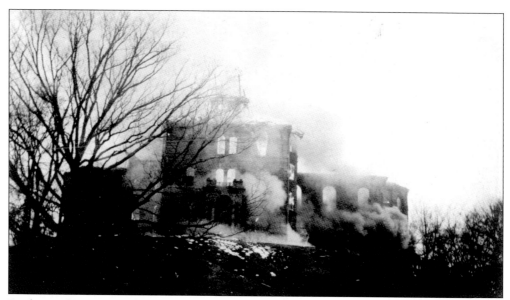

In the early morning hours of March 17, 1914, a fire broke out on the fourth floor of College Hall. It spread quickly, and the building that took four years to build was destroyed in four hours. Amazingly, not a single life was lost, thanks to the fire drill system. The Japanese bell roused the residents, 216 students and faculty, and all evacuated the building in about 10 minutes.

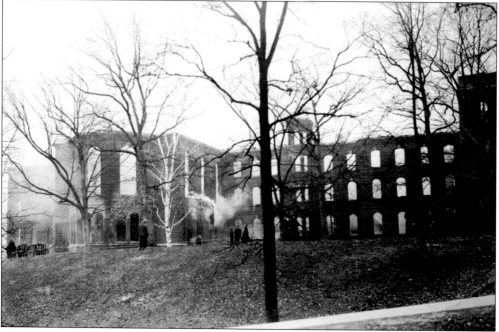

Once safely outside, they immediately formed a fire line to save all that could be saved, passing precious artwork, books, and college records down the line to the safety of the library. Despite the heroic efforts of all involved, including firemen from five towns, much was lost in the devastating fire, which took place 44 years to the day after the signing of the original charter for Wellesley College.

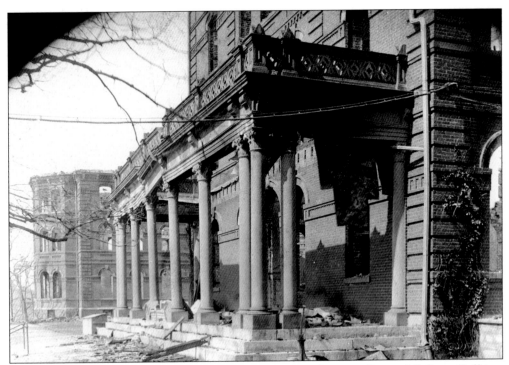

"The unbelievable is true," wrote Wellesley president Ellen Pendleton. "College Hall is a ruin. But it is stately and majestic in its desolation, and it inspires us to face the future with courage. While we rejoice that no life was lost, we must grieve that College Hall, which was the visible habitation of precious memories and dear associations, is gone; but we know that no fire can take from us Wellesley women our heritage, invisible but steadfast."

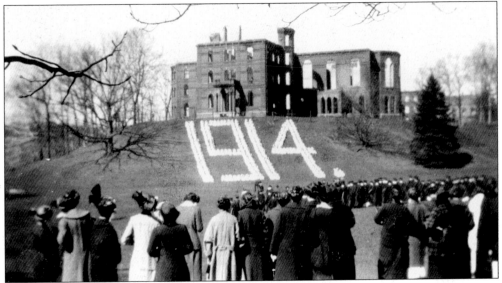

In Wellesley's traditional May Day celebrations, the sophomore class, all dressed in white, used to arrange themselves in neat rows on the hillside to depict their sister seniors' class numerals. In 1914, the ruins of College Hall loomed in the background, creating a haunting rendition of a traditional scene.

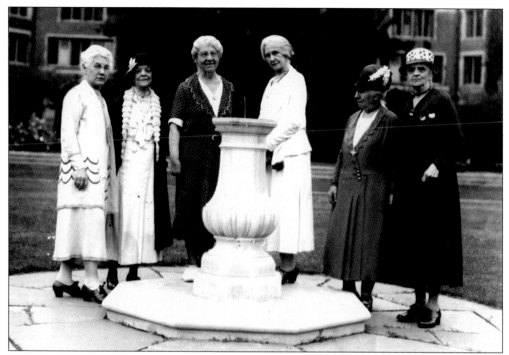

Wellesley did rebuild itself but never forgot its earliest history. One such reminder is the sundial in the courtyard of Tower Court, given by the members of the class of 1879, some of whom are shown here at its unveiling at their reunion in 1933.

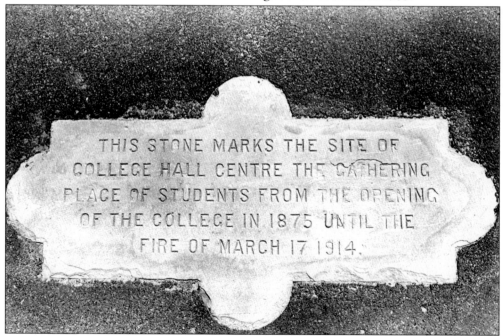

THIS STONE MARKS THE SITE OF COLLEGE HALL CENTRE THE GATHERING PLACE OF STUDENTS FROM THE OPENING OF THE COLLEGE IN 1875 UNTIL THE FIRE OF MARCH 17 1914.

The sundial was placed where College Hall Center once was, with this stone near its base. The unusual shape of the stone imitates that of the marble basin where the palms and greenery once flourished.

The sundial is not the only reminder of Wellesley's past on today's campus. In 1972, the class of 1917, led by Eleanor Blair, president of the alumnae class, resurrected five stone pillars from College Hall, which had been lying on college property for decades. The pillars were placed near the site of the south porch, overlooking the lake, and were dedicated (as shown here) during the class's 55th reunion—a precious and fitting gift to their alma mater from the women who were freshmen in the year of the fire and therefore the last class to know College Hall.

Two

PRESIDENTS

Wellesley College has had a woman president from the beginning, a feat that few, if any, colleges can claim. Henry Durant was determined to have an all-female faculty when Wellesley opened its doors in 1875, and his ideal included a woman to lead that faculty. He found Ada Howard, a Mount Holyoke graduate and head of a private school in New Jersey, to fill the position, although he exerted great influence in the way the college was run. When Alice Freeman became Wellesley's second president after Durant's death and Howard's resignation, everyone looked to her for the leadership and vision to move the young college forward. Without question, she provided it.

The 12 women who have steered Wellesley's course over 130 years have varied greatly in background and experience, but all have come to the presidency with dedication and a willingness to serve. Their common characteristics are evident. They have been leaders of the faculty, recruiting, retaining, and supporting talented women and men to educate women in the liberal arts. They have forged relationships with students, as role models and as intellectual authorities. And they have taken Wellesley out into the world, working to build its international reputation of excellence.

The job description of president has changed dramatically over the years. Early presidents spent much of their time simply running the college. With the advent of deans and other administrative positions by the 1890s, the president began to take on other roles and larger responsibilities. She became a visionary and a planner, thinking about how to carry the college and its mission into the future. And, increasingly, she became a fund-raiser, working beyond the campus to insure that innovative ideas and plans became a reality.

The portraits of Wellesley's presidents hang in the main reading room of Clapp Library, and a walk around the perimeter of that room is a walk through time. These distinguished women differ in manner and dress, each reflecting her era and presidential style, yet intelligent, capable, dedicated eyes gaze out from all of these portraits. Wellesley's presidents are a uniquely powerful group of women whose leadership down the years has shaped the history and stature of the college.

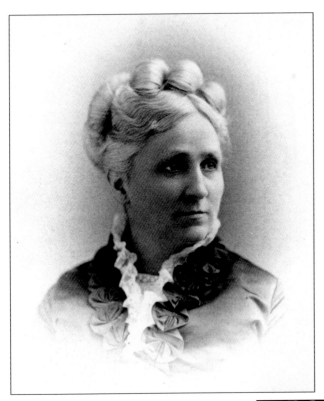

Ada Howard (1829–1907), a graduate of Mount Holyoke, was appointed by Henry Durant to be "President of the Faculty and various Professors and Teachers" in 1875. She held this position until Durant's death in 1881, when she resigned, citing poor health. During her six-year tenure, Durant was unquestionably the true leader of Wellesley, and this quiet, rather stern disciplinarian was his second-in-command.

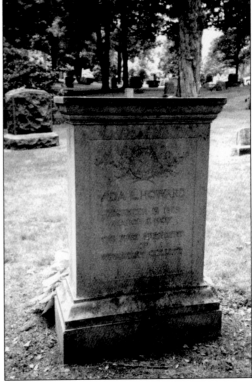

Through the generosity of Pauline Durant and faithful alumnae, Ada Howard was quietly supported for the many years she lived after leaving Wellesley and was often invited back for important occasions. Upon her death in 1907, she was buried in the Wellesley town cemetery, and the Alumnae Association had this stone made to mark her grave.

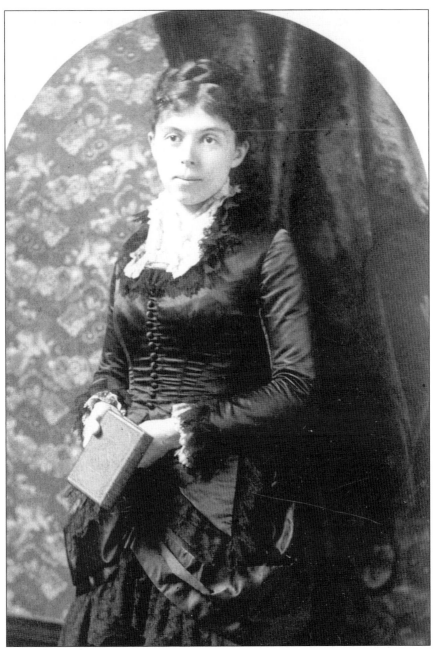

A graduate of the University of Michigan, Alice Freeman (1855–1902) came to Wellesley at age 24 as a professor of history in 1879. Two years later, after the resignation of Ada Howard, she was appointed president. The achievements of her six-year presidency laid the foundation for the future of the college. Academic Council was formed, departments were reorganized under the leadership of department heads, courses were strengthened and standardized, and entrance examinations were made more rigorous. The college grew and solidified immensely under her leadership. Students were extremely fond of their approachable young president, and she had a devoted following of alumnae, faculty, and trustees.

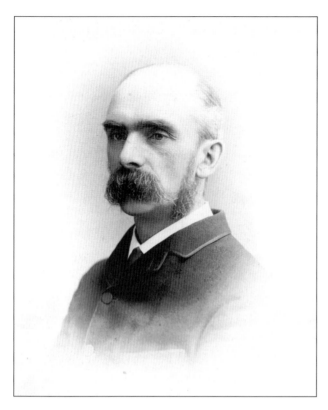

In 1886, Alice Freeman began a secret courtship with Harvard professor George Herbert Palmer. Her decision to marry him in 1887 led to her resignation as Wellesley's president. However, she remained a national educational leader and served as a Wellesley trustee for the rest of her life.

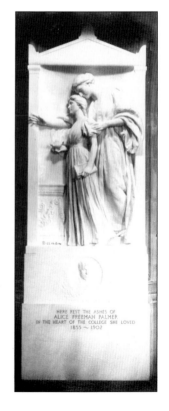

When she died in 1902, Alice Freeman Palmer's ashes were placed in this beautiful and eloquent memorial, designed by Daniel Chester French, in Houghton Memorial Chapel. George Palmer remained dedicated to the college for the rest of his life. He donated valuable books and papers to Wellesley each year on the anniversary of his wife's birthday, and upon his death in 1933, his ashes too were placed in the memorial.

Helen Shafer (1839–1894) had been a professor of mathematics at Wellesley for 10 years when she was chosen as Alice Freeman's successor in 1887. Her gifts, quite different from those of her predecessor, were essential to Wellesley's further growth. Under her guidance, a new curriculum was created, putting Wellesley on a sound intellectual path. Many were concerned about Wellesley's direction after President Freeman's departure, but publications of the time suggest that the entire community was grateful for Helen Shafer's calm, resourceful leadership. She died in office of tuberculosis in 1894.

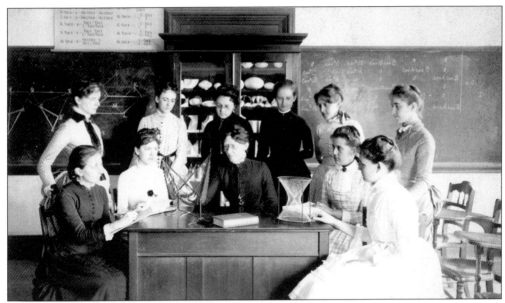

Helen Shafer sorely missed the classroom once she assumed the presidency. In this picture of a senior math class of 1886, Professor Shafer is seated in the center. Helen Merrill (class of 1886), who later was a mathematics professor at Wellesley for 39 years, is to her immediate left. Seated on the right at the end is Ellen Pendleton (class of 1886), who became a professor, dean, and president of Wellesley.

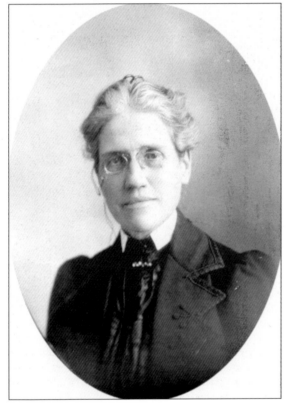

Julia Irvine (1848–1930) came to Wellesley as a professor of Greek in 1890. In 1894, when President Shafer died, she agreed to become Wellesley's next president, a position she held for five years. She focused her energies on implementing the new curriculum, a task that included restructuring academic departments and hiring and firing many faculty members. After her resignation in 1899, she lived in France for much of the rest of her life.

Wellesley looked in a new direction for its next president in 1899. Caroline Hazard (1856–1945) had neither administrative nor teaching experience and, unlike her three predecessors, was not a member of the Wellesley faculty. Yet the 11 years of her presidency were marked by remarkable growth of the college, the establishment of a strong financial foundation, and the construction of numerous buildings.

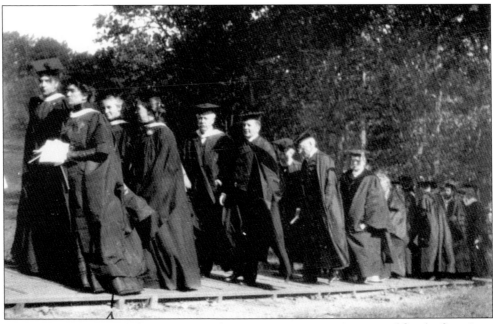

During the 1899 search for a new president, a man's name was proposed for the first time, but the idea was soon dropped. Pauline Durant said at the time, "If we get a man now, we will never again have the place for a woman in all probability." President Hazard's inauguration in the fall of 1899 was the first presidential inauguration at Wellesley and the first academic procession, as seen in this photograph.

One of the buildings constructed during Caroline Hazard's presidency was Oakwoods, built with her own personal funds to be the President's House and given to Wellesley upon her resignation in 1910. This stately house overlooking Lake Waban near Stone Hall served as the home of the president until 1926, when it became a dean's residence. Recently, it was expanded and converted into the college's admission office and renamed Weaver House.

After a year as acting president, in 1911, Ellen Fitz Pendleton (1864–1936), from the class of 1886, became the first Wellesley graduate to serve as president of the college. From her arrival on campus as a freshman in the fall of 1882 to her retirement in the summer of 1936, she rarely left Wellesley for more than a few weeks at a time.

Here, standing on the left, is Ellen Pendleton as a student. She was a member of the Shakespeare Society and was chosen by her classmates to be the "Receiver of the Spade" speaker on Tree Day in 1883. After graduation, she devoted her life to her alma mater, first as a professor of mathematics, then as dean of the college, and ultimately as president.

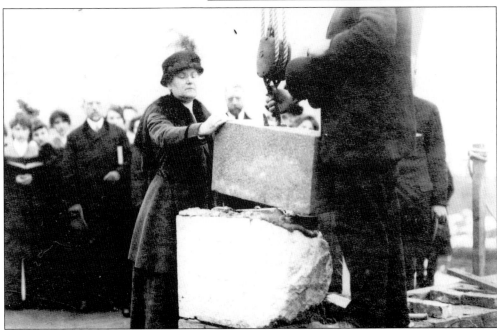

President Pendleton guided Wellesley through the difficult years of World War I and the Great Depression. Her most important contribution, however, was overseeing Wellesley's rebuilding after College Hall was destroyed in 1914. Here she is on January 15, 1915, less than 10 months after the fire, laying the cornerstone for Tower Court, the first of the dormitories built on the hill once occupied by College Hall.

Here, from left to right, are Wellesley president Ellen Pendleton (class of 1886); Sarah Whiting, professor of physics and astronomy; Edith Tufts (class of 1884), college registrar and later dean of residence; and Mary Frazer Smith (class of 1896), secretary to the dean. Mary Frazer Smith was best remembered for her heroic efforts at the time of the College Hall fire: not only did she rescue all the academic records from 1875 to 1914, but when she realized exam and class schedules had burned, she sat down that morning and recreated them entirely from memory. Collectively, these four women devoted 149 years to Wellesley: President Pendleton 48 years, Professor Whiting 40 years, Edith Tufts 28 years, and Mary Frazer Smith 33 years.

In 1936, Ellen Pendleton retired, celebrating both silver and golden anniversaries—her 25th year as Wellesley's president and her 50th reunion. She died suddenly a few weeks later, leaving little time for mentoring her young successor, Mildred McAfee (1900–1994), a 36-year-old graduate of Vassar.

In 1942, during World War II, President McAfee was chosen to direct the Women's Reserve of the United States Navy, known as the WAVES. As a commissioned officer on active duty during the war, she divided her time between Wellesley and the WAVES. When at Wellesley, as for this 1945 commencement procession with trustees, President McAfee appeared in uniform.

In August 1945, Mildred McAfee married Douglas Horton, a widower whose first wife and two daughters were all Wellesley alumnae. Unlike Alice Freeman Palmer, nearly 60 years earlier, she did not give up her presidency when she married. However, in 1949, she offered her resignation to the Wellesley College Board of Trustees, saying that she wished to join her husband in New York so that "as a team we can accomplish more than the sum of accomplishments of each of us working separately."

In 1949, Margaret Clapp (1910–1974), a class of 1930 alumna and lifelong educator, was chosen to be Wellesley's eighth president. A professor of history at Brooklyn College, she had been college government president her senior year at Wellesley and had won the Pulitzer Prize for her 1948 biography of John Bigelow.

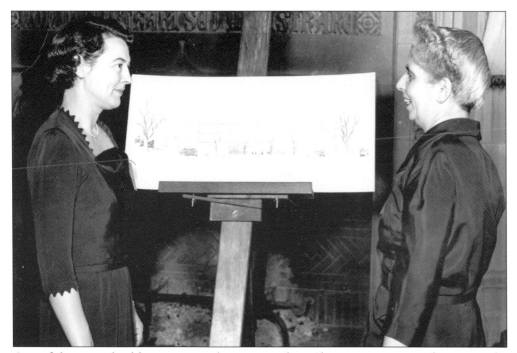

One of the many building projects during President Clapp's 17-year presidency was the expansion of the library in 1956. Here she and Margery Loengard (class of 1920), chair of the Library Building Fund Committee, accept the architect's sketch. Originally, a brand new library was to be built in the Academic Quad; however, a major donation for the Jewett Arts Center on that site led to the decision to expand and enhance the beloved, but severely overcrowded, library by the lake.

Margaret Clapp resigned in 1966, believing that it was time for Wellesley to have new leadership. The six-year presidency of Ruth Adams (1914–2004) included many new initiatives, such as the creation of the cross-registration program with MIT and the Continuing Education Program. During her tenure, the Commission on the Future of the College was convened, which culminated in the critical decision to remain an all-women's college.

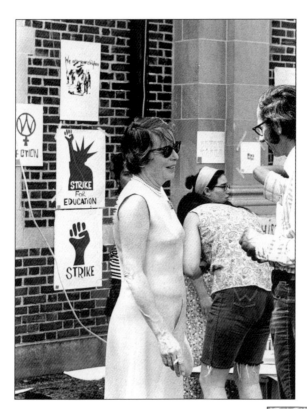

The late 1960s and early 1970s were challenging years on many college campuses, and Wellesley was no exception. Here, with strike posters in the background, Wellesley president Ruth Adams talks with theater professor Paul Barstow in 1970.

In 1972, when Ruth Adams resigned to become vice president for women at Dartmouth College, the presidential search committee, for the first time involving students as well as trustees and faculty in the search, chose Barbara Newell as Wellesley's next president. Consistent with her strong convictions about the importance of women's education and the power of women's colleges, she established Wellesley's pioneering Center for Research on Women in 1974.

After a leave of absence during which she served as U.S. ambassador to the United Nations Education, Scientific, and Cultural Organization (UNESCO), Barbara Newell resigned the presidency. In July 1981, Nannerl Overholser Keohane (class of 1961) became Wellesley's 11th president and the third alumna to lead the college. She was a student at Wellesley during the previous alumna presidency of Margaret Clapp (class of 1930), who herself was a student during the first alumna presidency of Ellen Pendleton (class of 1886).

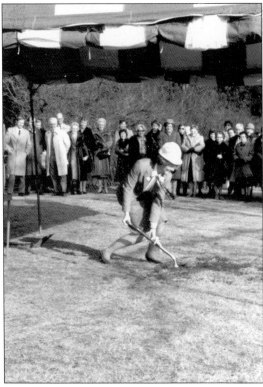

"Nan," as President Keohane was affectionately known, moved Wellesley forward in many directions. Under her leadership, Wellesley embraced multiculturalism, broadened the curriculum, and sharpened its sense of mission. She also undertook a fund-raising effort to replace Wellesley's outdated athletic facilities. Ground was broken on February 10, 1984, for a new sports center, which was renamed in Keohane's honor when she left Wellesley in 1993 to become president of Duke University.

In 1993, Diana Chapman Walsh (class of 1966) became Wellesley's 12th president and the fourth alumna to head the college. Under her leadership, Wellesley has undertaken a number of significant academic initiatives, including revision of the curriculum, innovative use of technology in teaching and learning, and the establishment of the annual Ruhlman and Tanner Conferences on student research and internship experience. In 2000, Wellesley celebrated its 125th anniversary and launched a five-year campaign, which raised $472 million, a record for liberal arts colleges. Following the 1998 Master Plan for the campus, the long-envisioned Lulu Chow Wang Campus Center was completed and dedicated in the fall of 2005, together with the newly created Alumnae Valley extending down to the lake.

Three

ACADEMIC LIFE

Even though there were few female college graduates in the 1870s—and fewer still with advanced degrees—Henry Durant searched long and hard to find capable, qualified women for his first faculty, which was comprised of seven professors and 11 instructors. In some instances, he offered excellent faculty candidates the resources and time to advance and deepen their knowledge of their disciplines before coming to teach at Wellesley.

In the beginning, Wellesley students followed a prescribed course of study, made up of classical and modern languages, mathematics, literature, history, elocution, and the sciences. In addition, all students studied the Bible, a requirement that, in one form or another, was part of a Wellesley education until 1968. A curriculum revision in 1893 stipulated for the first time "an area for concentration," which later became the major. Through periodic curricular reforms over the years, the heart of a Wellesley education has been the distribution requirements and the major, which together offer students the breadth and depth of knowledge that define a liberal arts education.

Throughout Wellesley's history, emphasis has been placed on good teaching. At the same time, the intrinsic and pedagogic importance of faculty research is acknowledged and celebrated. Many Wellesley professors were, and are, leaders in their fields, with national and international reputations. Henry Durant's all-female faculty policy gradually gave way to one of hiring the best candidates, regardless of gender. Men made up about 15 percent of the faculty by 1925, 25 percent by 1950, and 40 percent in 2006.

Although the College Hall fire in 1914 inflicted devastating losses of classroom space, equipment, books, and research, this destruction did not touch the heart of the intellectual enterprise. The young college simply renewed its commitment to giving young women a superlative education in the liberal arts. A 1916 alumna whose physics professor told her she had studied physics "at its lowest ebb" at Wellesley once wrote, "Whether this is so I do not know, but I do know that members of the faculty who did not spare themselves in order to give their students the best possible education under these trying conditions have inspired me more than any equipment."

Indeed, it is the inspiration of countless professors for over 130 years—their research, their innovative teaching, their high standards, their intellectual rigor, and their accessibility to their students—that is one of the hallmarks of a Wellesley education.

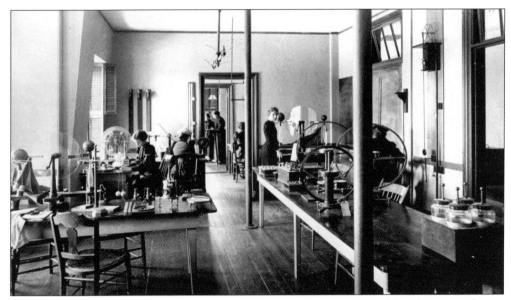

The physics laboratory in College Hall, seen here in 1893, was created by physics professor Sarah Whiting in 1878, and was the second undergraduate experimental physics laboratory in the country (the first was at MIT). Appointed to the faculty in 1876, Professor Whiting was given two years to investigate various university laboratory facilities before setting up her Wellesley department and laboratory in the only space available—the fifth-floor attic of College Hall.

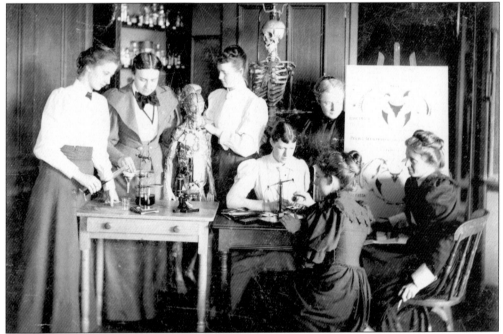

Henry Durant believed that students would gain as much from hands-on experiments as from teachers and books. So, early on, laboratories became key to science instruction at Wellesley. Here is a physiology class from around 1894. Martha Hale Shackford (class of 1896), later a professor of English for 42 years, is seen fourth from the left.

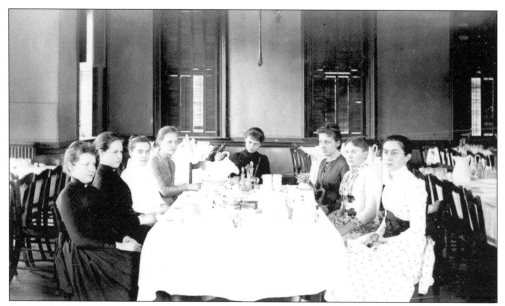

From the beginning, Wellesley's professors and students shared a strong common bond—pioneers together, they formed a tightly knit community in College Hall. Intellectual connection and interaction between faculty and students was strongly encouraged. Here, for example, Fraulein Carla Wenckebach, head of the German Department, is seen second from the right with her students at the German Table on May 17, 1889.

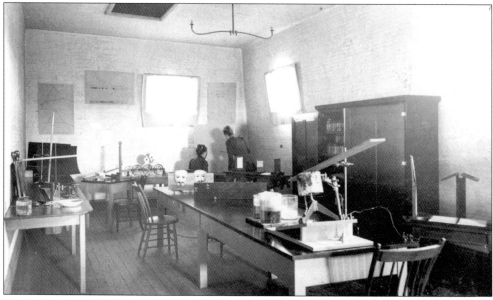

Psychology was just becoming accepted as an experimental science when the versatile professor Mary Whiton Calkins established an experimental psychology laboratory at Wellesley in 1891. Like the physics laboratory, it was one of the first of its kind in the country.

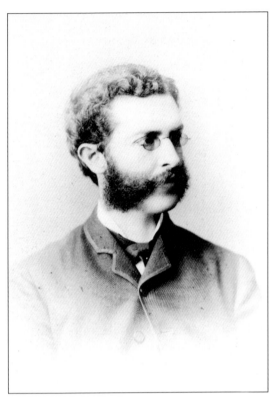

Among the trailblazing women faculty in the early years, there was one lone man. Charles Morse was appointed to be director of the Music Department in 1875, a position he held until 1884. A few men followed Morse in the 19th century, but they remained a minority.

Katharine Lee Bates (class of 1880) devoted her life to Wellesley. In 1885, she returned to her alma mater to teach in the English Department and retired as Professor Emerita of English Literature 40 years later. Nationally, she is known as the author of "America the Beautiful," first published in 1895 and today sung at every Wellesley commencement. She is pictured here in 1916 with Hamlet, one of her beloved collies.

Emily Greene Balch, shown here in 1914, was an economics professor for 22 years at Wellesley and an avowed pacifist. During World War I, she took a two-year leave to work for peace, and, in 1919, she was not reappointed. The liberal members of the college community protested, believing that the trustees had dismissed her because of her political views, although there is no hard evidence of this. In 1946, she was awarded the Nobel Peace Prize.

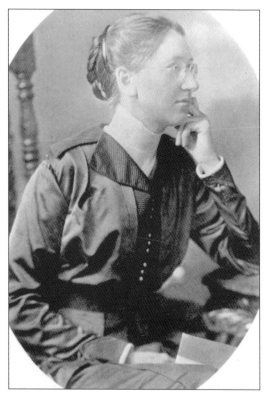

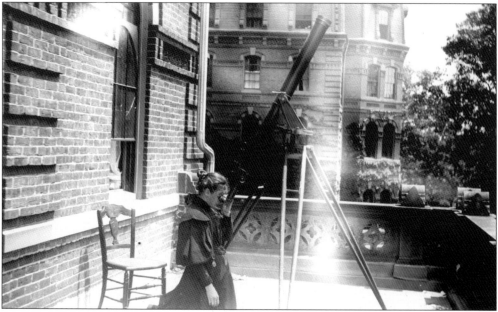

Sarah Whiting, the professor who established Wellesley's Physics Department, began teaching astronomy classes to seniors with a four-and-a-half-inch telescope for measurement and apparatus from the Physics Department for spectrum work. One early student, Annie Jump Cannon (class of 1884, seen here with the telescope outside College Hall), became a pioneer in the field of astronomy.

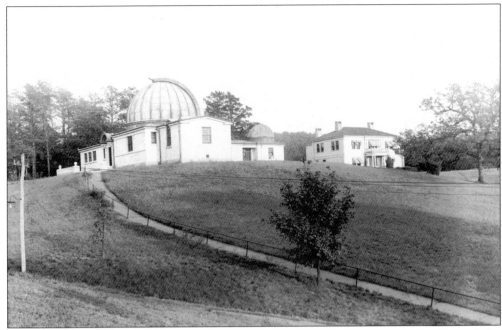

In 1900, the Whitin Observatory opened with a 12-inch telescope that allowed for sophisticated measurement and observation. In 1906, the observatory was expanded, a six-inch telescope added, and Observatory House (on the right) was built to house faculty. This photograph shows the observatory's original main entrance, which today is the back of the building.

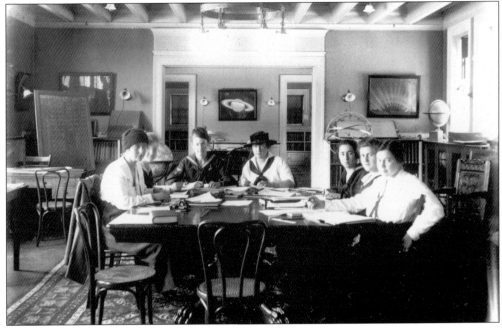

In 1905, astronomy became its own department, no longer listed under physics and applied mathematics. Students here in 1917 are working in the room that currently houses the astronomy library.

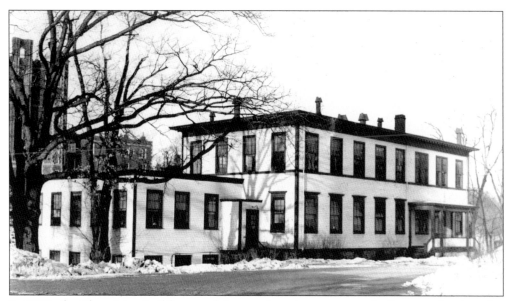

In 1895, the Chemistry Building, a plain wooden structure, was built near what is today Munger Meadow. (Shafer Hall is seen in the background of this 1932 photograph.) This simple building, a visual reminder of Wellesley's minimal financial means in the 1890s, housed the Chemistry Department for 40 years. In 1935, when Pendleton Hall was completed, all the laboratory equipment was carried up the hill to the new building, and the old building was destroyed.

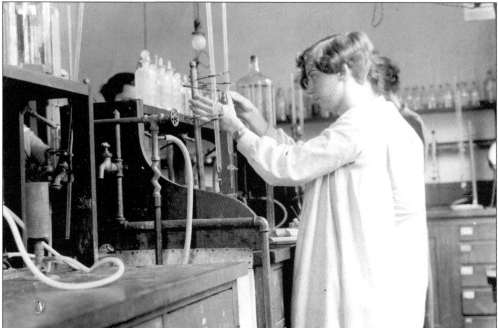

The Chemistry Department, fortunate to have its own building, was not affected by the College Hall fire as many of the other science departments were. After the fire, any available space was shared, and for a time, the Physics Department was housed with chemistry in its building. Pictured here are chemistry students at work in the 1920s.

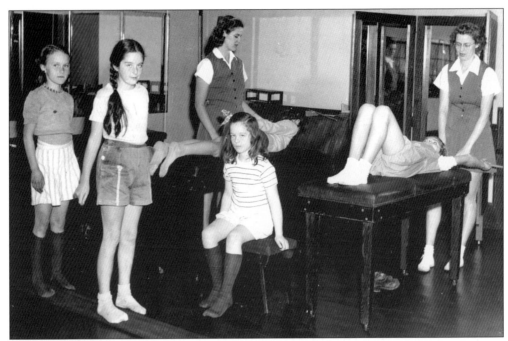

The Boston Normal School of Gymnastics, founded in 1889, was absorbed by Wellesley in 1909, and the Mary Hemenway Gymnasium was built to accommodate the program. Between 1909 and 1953, Wellesley offered graduate degrees through its Department of Hygiene and Physical Education (HPE). Here in 1930, as part of their training, graduate students give corrective exercises to local children.

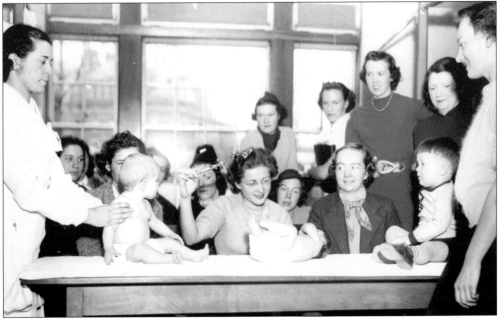

Experiential learning has long been an integral part of Wellesley's academic program. In 1937, an education class traveled to Boston Hospital for their course on Education of Young Children.

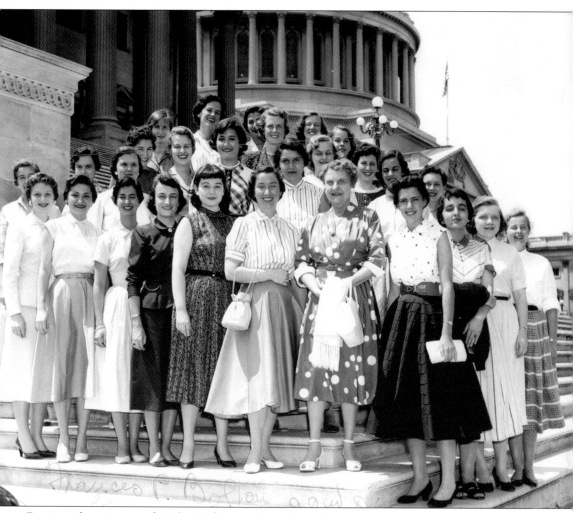

During the winter of 1942–1943, wartime fuel shortages mandated an extended winter break. Political science professor Julia Henderson took advantage of this by placing some of her students in government agencies in Washington, D.C., as unpaid volunteers. From this experience, the Wellesley Washington Internship Program was born. A year later, it became a summer program, with students working in nonpaying internships in a variety of fields. For some years, students from other schools were eligible for the program, and this led to a 13-year partnership with Vassar. Barbara Newell, Wellesley's 10th president, was a Washington intern in this program when she was a Vassar undergraduate. In this 1955 photograph, Wellesley and Vassar interns meet on the Capitol steps with Congresswoman Frances P. Bolton from Ohio. Over 50 years later, the Wellesley Washington Internship Program still provides invaluable summer opportunities for students.

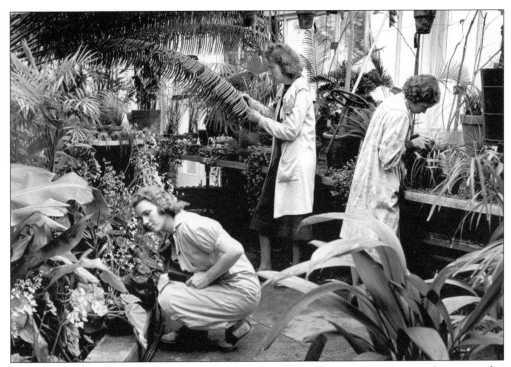

The original campus greenhouses, part of the Durant estate, were turned over to the Botany Department when Pauline Durant died in 1917. All but one were razed when new greenhouses were built in 1922. Today the greenhouses, named for former botany professor Margaret C. Ferguson, contain over 1,000 varieties of plants, including a cameilla given by the Durants.

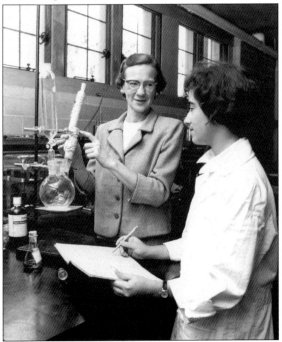

Chemistry professor Jean Crawford is pictured here with Dorothy Garfield, who received both a bachelor of arts degree and a master of arts degree from Wellesley in the 1950s. Beginning in 1882, with two students in the Greek Department, Wellesley offered master's degrees in small numbers in some departments. By the 1970s, only the Art and Biology Departments still accepted graduate students, and in 1975, graduate programs were discontinued.

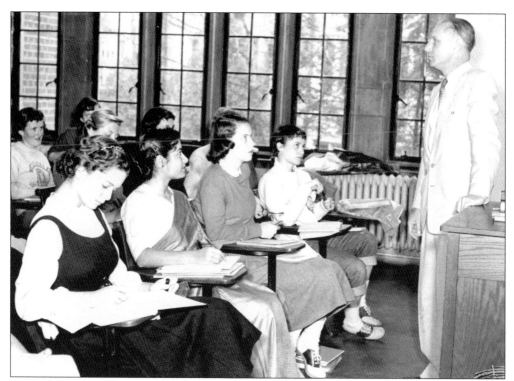

In a typical post–World War II class, this one taught by biblical history professor Herbert Gale, student dress reflects the transitional time. Skirts and a sari for some, jeans and sweatshirts for others—the years of proper, formal dress at all times were coming to an end. Saddle shoes, however, seem to go with everything.

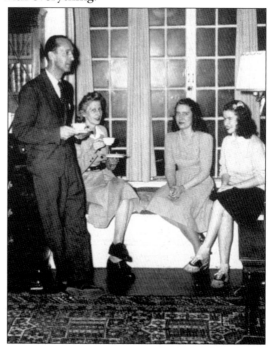

Connection and conversation between professors and students beyond the classroom pass the test of time. Here Vladimir Nabokov—acclaimed novelist and critic and founder of Wellesley's Russian Department—and his wife have tea with students in a society house in the 1940s.

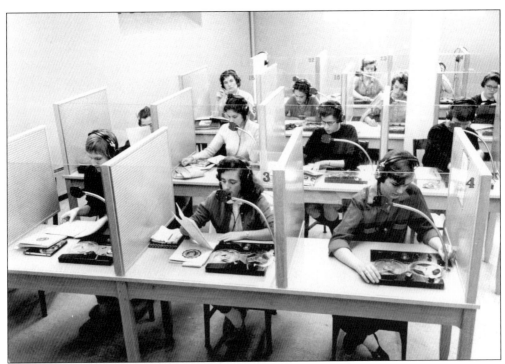

A 1959 article in the *Wellesley Alumnae Magazine* noted, "One of the newest concepts in language learning is embodied in the flexible teaching devices of the new Wellesley language laboratory." After years of discussion, a state-of-the-art language lab was created as a part of the newly expanded library, revolutionizing the teaching of foreign languages.

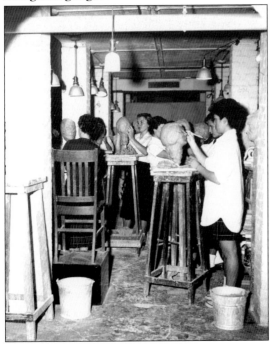

Around 1900, Alice Van Vechten Brown, head of the Art Department, helped pioneer the idea that if art history students combined appreciation and practice, the hands-on studio work would deepen their understanding of the artworks they were studying. Before Jewett Arts Center, art classes were held in Farnsworth Art Building, often in the basement "catacombs," as is the case for this sculpture class.

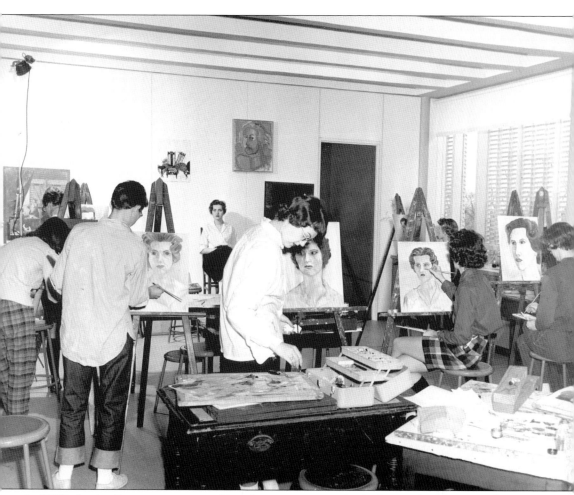

In 1958, the Art Department moved into its new quarters in the Jewett Arts Center, where this painting class is taking place. Over time, however, it became clear that more studio space was needed. In the late 1970s, with the completion of the Science Center, the Chemistry Department vacated the west end of Pendleton Hall, and the Art Department moved many of its studio courses into what had been laboratory rooms there.

Teaching was a popular career path for many of Wellesley's early graduates. Early courses in pedagogy were organized into a department of pedagogy in 1898, which was renamed the Education Department in 1909. Students began visiting neighborhood schools for observations, which eventually led to student teaching placements and an official teaching certification program. Here Terry Berman (class of 1973) is working in a Barnes Junior High School class in 1971.

In 1968, Wellesley began a cross-registration program with MIT, allowing men to participate in Wellesley classes for the first time. Here, in a language class taught by professor of Chinese Helen Lin in 1969, Diem Lieng, a class of 1970 MIT graduate, on the far right, listens attentively.

The Continuing Education Program, established in 1969, brought to campus older women and the perspectives and insights of their varied and complex lives. Like their traditional-aged counterparts, their goal was—and is—a Wellesley bachelor of arts degree. Dorothy Menell, a nurse and mother, is seen here in a class in 1972, along with a couple of men from MIT. In 1993, the program was renamed for Elisabeth Kaiser Davis (class of 1932) and continuing education students are now known as Davis Scholars.

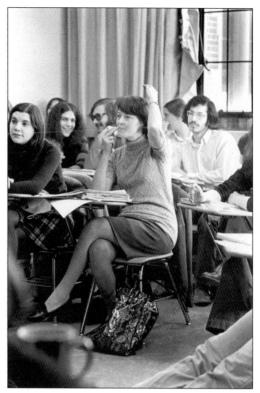

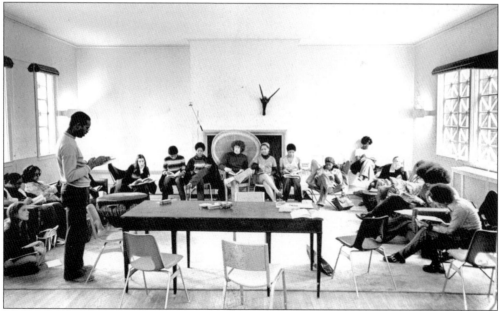

Africana Studies began as an interdepartmental major in 1968 and became an academic department in 1973. Here English instructor Glenn McNatt teaches Black Literature in America in Harambee House. Originally the Alpha Kappa Chi society house, Harambee (which means "working together" in Swahili) became the cultural center for African American students in 1970.

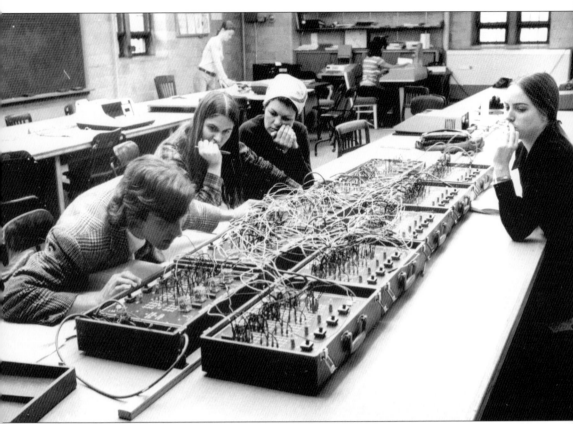

Some academic departments, such as Greek or mathematics, have existed since Wellesley's earliest years. Others, such as computer science, could not have been imagined 130 years ago. The look of this 1974 computer science class, which would have been wholly futuristic to a 19th-century student, seems quaintly historic to our eyes.

Four

STUDENT LIFE

The experience of a Wellesley student is more than the curriculum, classes, and professors that define her academic life. There has always been occasion and opportunity for "life outside the classroom"—for reflection and companionship, for informal socializing, and for organized extracurricular activity.

At first, the daily schedule for Wellesley students, which included silent devotional time and domestic chores as well as academic work, left room for little else. However, since those early students were rarely permitted to leave the college grounds, and since their beautiful campus seemed to invite and encourage imagination and creativity, they soon found ways to entertain themselves and complement their studies. Dramatic and musical activities began to flourish, with productions and performances for the entire community; student publications soon became a lively forum for discussion, opinion, and art; and membership in Wellesley's societies drew students together for gatherings devoted to shared special interests.

Throughout the college's history, much of student life has centered around the residence halls. Along with the organized activities of residential life—the intramural sports, the parties, the trivia contests—are the equally important and defining spontaneous moments that help form and nourish lifetime friendships. In addition, places such as Alumnae Hall, the Well, Schneider College Center, and the new Lulu Chow Wang Campus Center have been and are welcoming spots for relaxed socializing. They also have provided space for meetings and performance, for student government, clubs, and service organizations, and for the collective creativity of student publishing and radio programming.

Wellesley's campus itself shapes student life in an elemental way, beckoning students outdoors. Whether in sports and athletic events, or a walk around Lake Waban, or the simple pleasure of ice-skating on a cold winter day, generations of Wellesley students have found recreation and renewal in their campus in all seasons. The photographs in this chapter offer a glimpse of the variety and richness of student life.

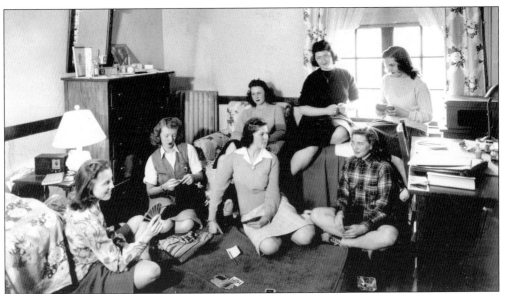

Wellesley has always been a residential college, where nearly all students live in dormitories on campus during their undergraduate years. The homelike environment nurtures the friendships that have defined the Wellesley experience from its first days. These card players and knitters in 1942 might just as easily be students of the 1880s or 1990s, for getting together in a friend's room is a perennial event, and timeless.

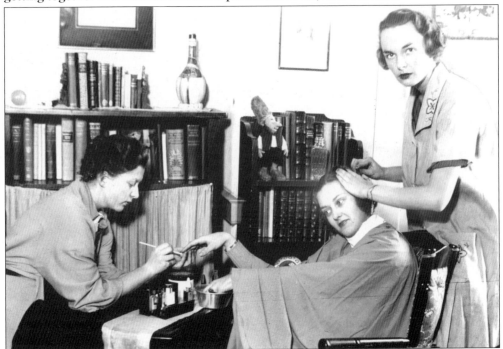

Life in the residence halls has always included fun and frivolity as well as study. This photograph from 1935, titled "Beauty Shop" on the back, shows Barbara Lieberman (class of 1937), Carol Parker (class of 1937), and Louise Riley (class of 1935) indulging in manicures and new hairstyles.

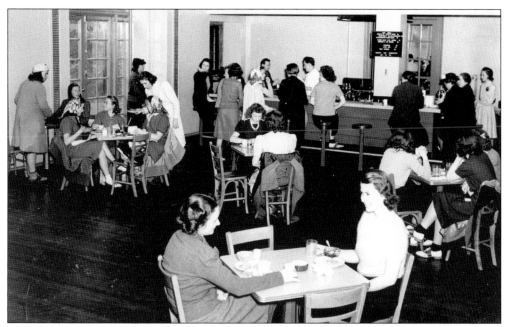

In addition to dormitory living rooms and common spaces, there are many spots on campus for students to gather and socialize. In October 1939, the Well, a soda fountain and lunchroom, opened in the ballroom of Alumnae Hall. For many years, students and faculty congregated here to enjoy snacks, meals, or late-night ice cream.

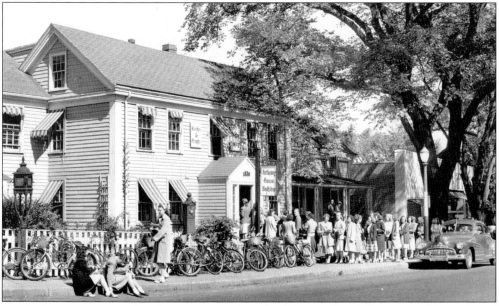

In 1925, a cooperative bookstore opened in the historic frame house at the corner of Central Street and Weston Road. Named Hathaway House Bookshop, it served for years as Wellesley College's bookstore, where generations of students waited patiently in line each semester to buy their textbooks. In 1976, the college decided to open and operate a bookstore on campus for the purchase of textbooks and supplies, and Hathaway House Bookshop closed its doors a few years later in July 1979.

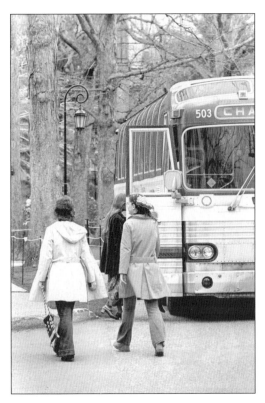

Until the 1960s, Wellesley students relied on public transportation to travel to and from Boston and Cambridge. The establishment of the Wellesley-MIT Exchange Program in 1968, however, created a pressing need for direct student transportation between the two schools. The "exchange bus," as it was called, became an easy and convenient way of getting into the city to take advantage of the academic, social, cultural, and internship opportunities there.

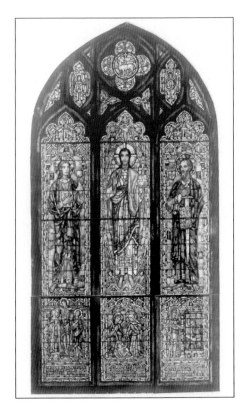

Religious life was an integral part of the early community at Wellesley. The Durant Memorial Windows in the chapel, given by the alumnae in 1925, are a reminder of the importance of religion in the founding of the college. The imagery in the stained glass panels, seen here, evokes the twin themes of love and service.

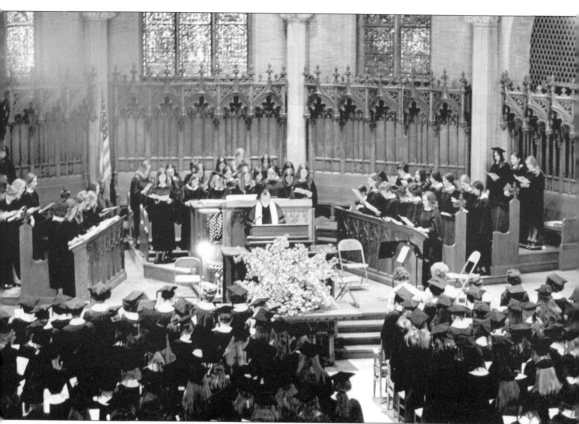

Early Wellesley students attended daily Bible classes as well as daily and Sunday chapel services. By 1895, daily chapel attendance was no longer required, and, although Sunday attendance was expected, students could choose to go to a village church instead of services in College Hall. Daily Bible classes were replaced with Bible and religious studies as a part of the curriculum. For generations of students, biblical history was an integral part of their Wellesley experience. In the 1960s, the biblical history requirement was dropped from the curriculum. Services, such as the baccalaureate service seen here, still might be held in the chapel, but they came to reflect the increasingly multi-faith and multicultural composition of the current study body.

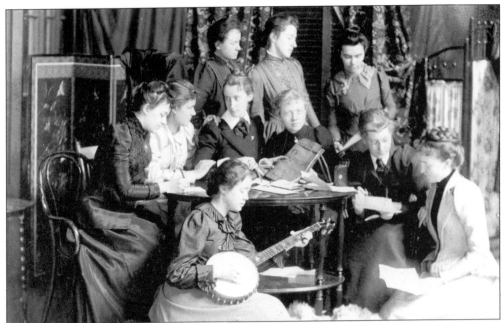

Wellesley students began publication of the yearbook, *Legenda*, in 1889. The book (seen on the table in the center), produced by these *Legenda* board members in 1892, was quite different from the modern version. Early yearbooks were primarily text, with information on students, events, clubs, and societies as well as humorous essays on college life. Gradually over time, yearbooks became collections of photographs and senior portraits.

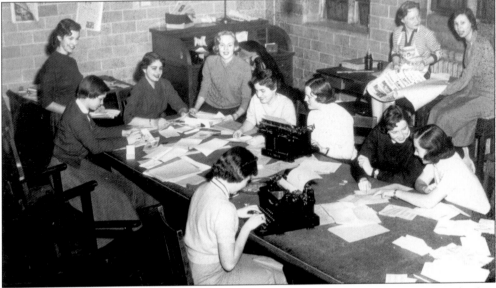

In the fall of 1901, *The College News* (later renamed *Wellesley News*) was launched as a weekly newspaper. It originally cost 5¢ and later was distributed for free. News staff shown here in 1958 included Madeleine Korbel Albright (class of 1959, seated at the table, fourth from the right), who later became the United States secretary of state under President Clinton.

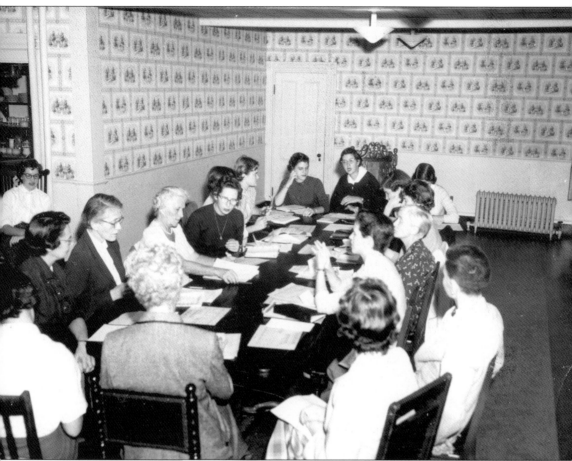

The beginnings of a student government can be traced back to Wellesley's second year; however, it was not until June 7, 1901, that the Student Government Association was officially established. It had little power until a reorganization in 1918, when a Senate with both student and faculty members was created. In the early years, discussion centered on norms of student conduct—in particular, matters such as chaperonage and smoking. Later debate focused on a student's right to complete autonomy in her social activities and choices. In this photograph, the Senate meets in November 1955, with college government president Maud Hazeltine Chaplin (class of 1956), later a long serving philosophy professor and dean at Wellesley, presiding at the meeting in Norumbega. Wellesley president Margaret Clapp and dean of students Teresa Frisch are seated on the left.

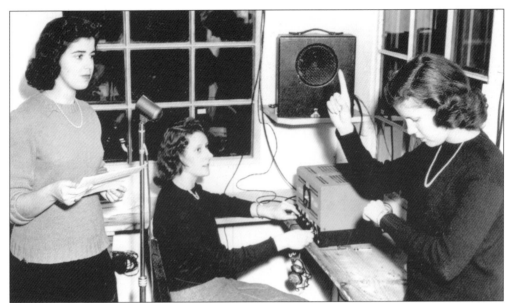

The singing of "America the Beautiful" launched Wellesley's radio station in Pendleton Hall on April 20, 1942. Originally called WBS, and later renamed WZLY when it became an FM station, it was the first independent radio station to be established at a women's college. Beginning with modest broadcasting hours (two hours a day, three days a week), it soon became a mainstay of college life. The radio station later broadcast from Green Hall, Alumnae Hall, and Schneider Center.

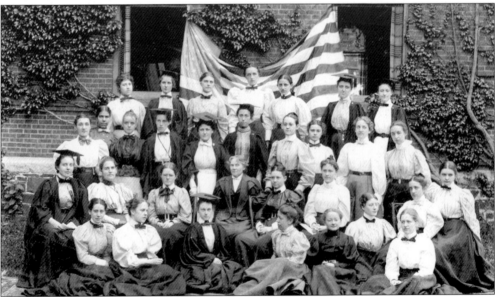

For many years, student life for many Wellesley students included membership in one of Wellesley's "societies." The political society Agora was formed in 1891, and, for a time, its membership included both students and faculty, as seen here in 1897. The group sponsored political speakers and held debates, particularly during election season. Agora's philosophy was that knowledge should catalyze action—foreshadowing modern student activism.

In addition to Agora, literary and art societies were formed in Wellesley's early decades. Around the beginning of the 20th century, they were given permission by the college to build small houses for meetings and social functions. Here members of Tau Zeta Epsilon (TZE), an art society, pose for a group picture taken in 1940 in their house by Lake Waban. Although societies began as extracurricular clubs intended to enrich and complement students' academic experience, over time they became more social than intellectual. In the 1950s, the administration intervened to insure that all students who wanted to join a society could do so. Today societies are only one of an array of organizations to which Wellesley students belong.

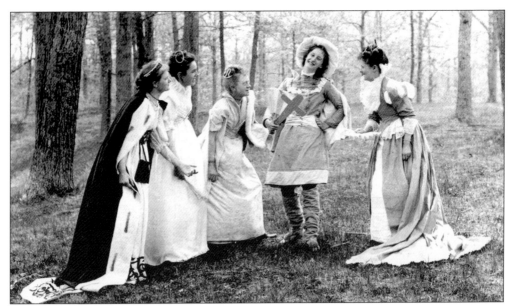

Shakespeare Society, begun in January 1877, devoted itself to the study and staging of Shakespeare's plays and provided wonderful dramatic performances during an era when Wellesley students were not allowed to attend theater productions off-campus. Shakespeare Society's first performance was *As You Like It* in 1889; here cast members of *Love's Labor's Lost* in 1891 pose for the camera. Shakespeare Society still stages two productions a year.

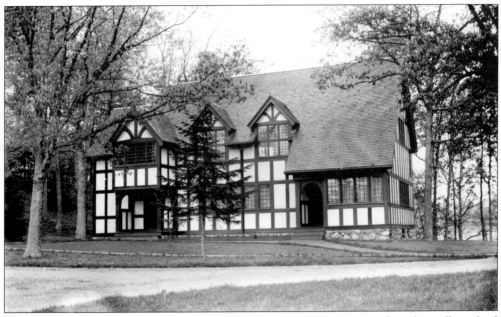

Shakespeare Society was the first society to build its own house after the college had given the societies permission to do so. Shakespeare House, an Elizabethan-style building with a large meeting room downstairs and a performance hall upstairs, was built in 1898, near the bottom of the hill leading up to College Hall.

The barn on the land the Durants purchased in the 1850s housed the college's cows for many years. Expanded over time, students began using it as an "exercise and recreation building" in 1896. It was the site of plays, receptions, and other social events until Alumnae Hall was built in 1923. "The barn," as it was called, was later completely renovated and became Dower House, a residence hall.

Formed in 1896, Barnswallows was an organization open to all students. Its original purpose was purely social, and it offered informal entertainments of all kinds; by 1920, it became the drama organization on campus. In 1922, these students gave a performance on the barn stage of a student-written operetta titled *Right About Face*.

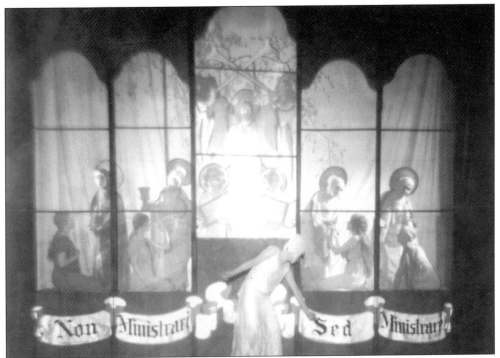

In 1925, Wellesley celebrated its semicentennial in grand fashion. The highlight of the yearlong festivities was a pageant titled *The Winged Soul*. This scene takes place in "Episode Three: Beauty of the Spirit." Ellen Bartlett (class of 1927), in the foreground as the title character, walks in front of "The Stained Glass Window," meant to evoke the Durant Memorial Windows unveiled in Houghton Memorial Chapel just the day before.

In addition to theatrical activities, musical opportunities have always flourished at Wellesley. The Glee Club, formed in 1889, started out with college songs such as "The College Beautiful" and "Alma Mater." By the time these members posed in 1921, many more songs had been added to their repertoire. In the early years of the college, Glee Club concerts were one of the few events on campus to which men might be invited.

Over time, Wellesley students began forming a cappella groups. One such group, the Tupelos, was established in 1950, when a few students listening to their dates from a Yale a cappella group harmonize together, realized they could do the same. The group they formed was named after the popular lakeside campus landmark Tupelo Point.

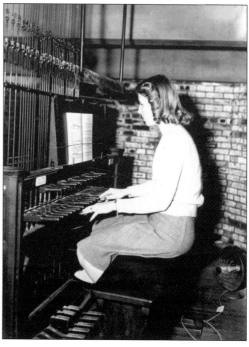

When Galen Stone Tower was built atop Green Hall in 1931, it contained a 30-bell carillon, one of the few in America. Soon the Guild of Carilloneurs was formed, a group of students such as Ruth Wick (class of 1948), seen here, who devote themselves to playing the carillon. For over 70 years, the college community has found comfort and joy in the songs reverberating from the tower at both planned and unpredictable times.

Wellesley's global reputation goes back more than a century. Kin Kato from Japan was Wellesley's first international student, attending for one academic year in 1888–1889. Others followed her, although it was not until 1912 that an international student, Jitsuye Koike Takehara, also from Japan, earned a Wellesley degree. Today international students make up about eight percent of the student population.

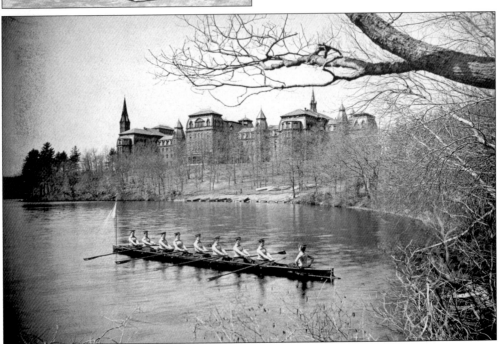

Henry Durant believed fervently in physical exercise for the young women at his college, and athletic activities of all kinds have always been an integral part of student life. Boats were available to students for rowing in Wellesley's very first year, and within a decade, crew became one of the most popular sports on campus. The class crew of 1894 is seen rowing here on Lake Waban near College Hall.

Intercollegiate athletics were not allowed by Wellesley until the end of the 1960s. Until that time, intramural sports between classes or dormitories were the arena for student athletic competition. These basketball players, around 1948, demonstrate their skill in the gymnasium of Mary Hemenway Hall.

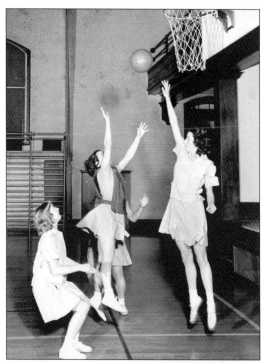

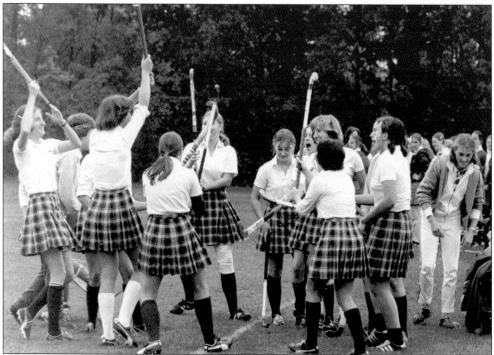

Wellesley joined the Eastern Association for Intercollegiate Athletics for Women in 1972, the same year that Title IX, assuring equal opportunity for women in sports, was enacted. By 1977, the year these field hockey players raised their sticks in triumph after a match, Wellesley had established itself as a strong and competitive athletic presence.

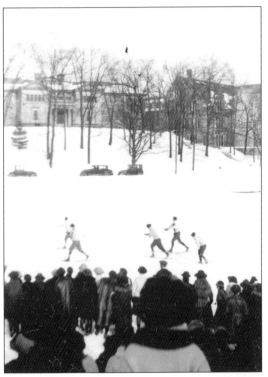

The beauty of Wellesley under a snow cover of winter white is irresistible. In 1921, the Outing Club created a winter carnival, complete with skating, skiing, tobogganing, and a host of other outdoor activities. A ski dash is in progress here during the Winter Carnival of 1923. Unpredictable weather made it difficult to establish Winter Carnival as an official annual event, but valiant and playful versions of it continued for many years.

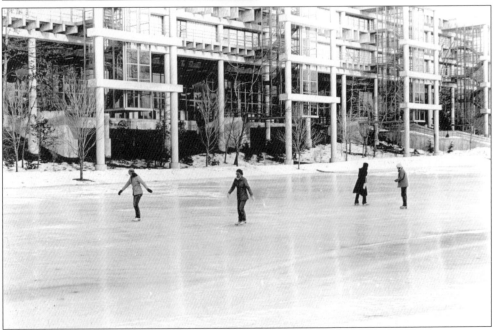

Nature created a wonderful impromptu skating rink in front of the Science Center in the winter of 1978. After a wet, rainy beginning to the season, a quick deep freeze made for flawless ice in the undrained meadow. This happened again a few times over the next two decades until the drainage was improved—an environmental imperative and at the same time a loss of winter delight.

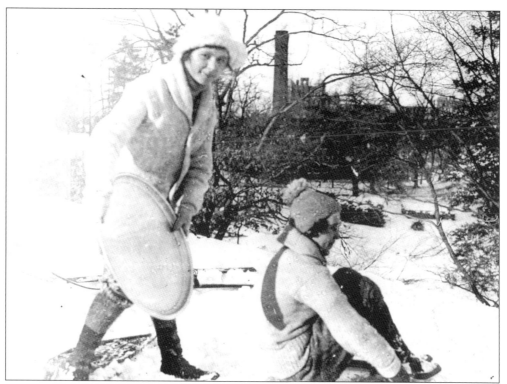

The splendor of Wellesley's campus is timeless, and winter can bring out the inner child in even the most serious student. In the 1920s, these students are "traying," or sledding on large dining hall trays, down Severance Hill. The power plant smokestack is visible in the background.

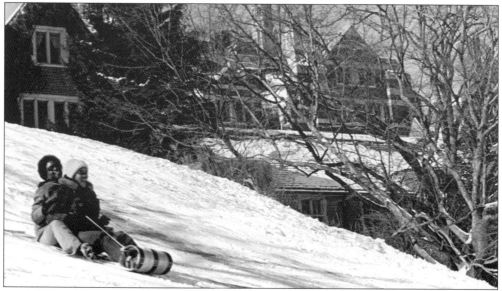

Some things do not change—same hill, different sled, decades later. Although dining hall trays are still a popular means of coasting down the hill, these students in 1974 found a wooden sled for their adventures.

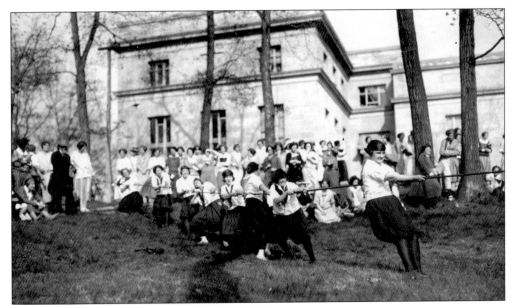

Spring comes eventually to New England and to Wellesley's campus. An annual daylong spring Field Day was established in 1899, complete with tennis and golf tournaments, basketball matches, and other activities such as a three-legged race, a 50-yard dash, and a tug-of-war. Here, in the spring of 1923, the classes of 1923 and 1924 face off beside the library building.

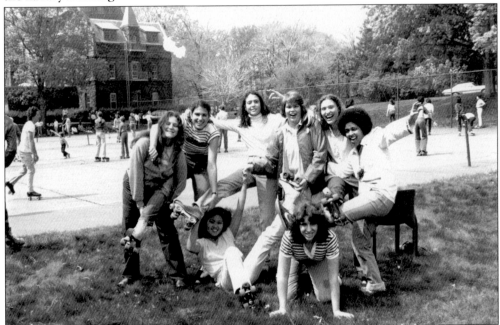

Wellesley's outdoor festivals have evolved with the times. In the 1970s, Spring Weekend began, with barbeque picnics, open-air concerts, and other seasonal activities during a weekend in late April. For some years, the tennis courts near Schneider Center were transformed into a roller rink for a few hours during Spring Weekend, as seen here in 1981.

Five

TRADITIONS

Wellesley students down the years have used their considerable imagination to devise ways to balance the responsibilities of academic life. Many of the activities and events created in this spirit were repeated year after year and became traditions. Wellesley's traditions are meant to connect students with one another, to initiate newcomers, to create a moment of fun, camaraderie, and joy, and to give participants the pleasure of sharing in a ritual that has been performed, sometimes for decades, by generations of Wellesley students.

What makes an event or practice a tradition? Within 40 years of Wellesley's founding, the college calendar was so filled with plays, dances, and other activities, all labeled "tradition," that a concerted effort was made to reduce the number of these events so that those remaining would hold special importance. Since then, some new traditions have been born, some old ones have died out, and some have been transformed; others are still going strong today, in some instances over 100 years after they began.

Traditions were and are a part of Wellesley's community identity. They were used to help define the college in some of the earliest publications, allowing the outside world to understand what it meant to be a Wellesley student: she participated in Tree Day, she rolled her hoop on May Day, she rowed in a crew on Float Night. The golden age of these particular traditions (from the 1890s to the 1930s) was a time of intense interest in Wellesley as a new institution created for a new purpose—the higher education of women. The traditions, ritual celebrations, and ceremonies on campus were often a focus of the press coverage of the college at that time.

To depict the traditions at Wellesley, the photographs in this chapter are arranged not in chronological order but according to the unfolding of the academic year.

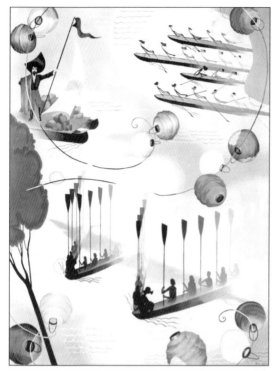

The Well, the soda fountain and lunchroom on the first floor of Alumnae Hall, opened in 1939. It was briefly relocated to one of the society houses when the Navy Supply Corps, housed on campus during World War II, used the space for its canteen. After the war, students gladly saw the return of the Well to Alumnae Hall and decided some new decorations were in order. In 1945, these four murals were painted on the walls.

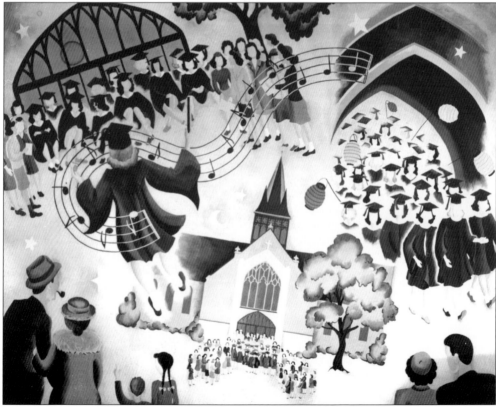

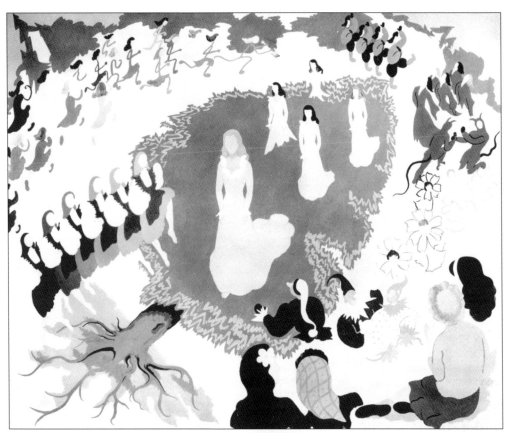

The murals were designed and executed by the members of the art composition classes under the direction of art professor Agnes Abbot. They depicted Wellesley's four most significant traditions: Tree Day and Hoop Rolling (on this page) and Float Night and Step Singing (on the opposite page). The whimsical details of these murals are extraordinary, capturing the sense of fun, excitement, and pure joy that students found in these traditions.

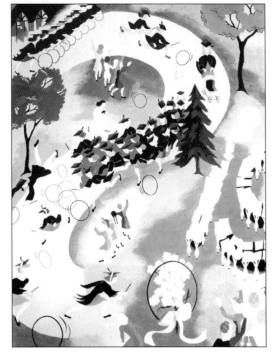

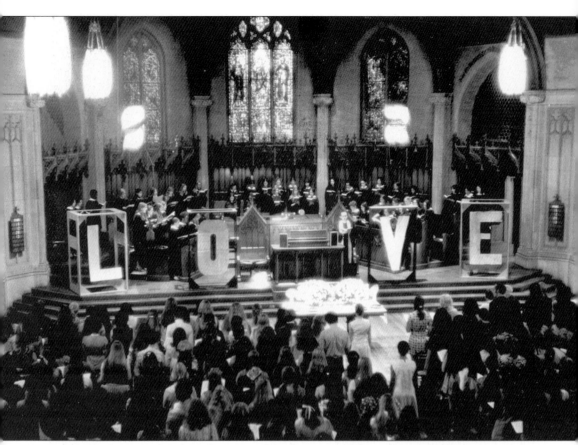

During the first Sunday chapel service of the first year of the college in 1875, an insensitive visiting minister preached a sermon that caused fear, trepidation, and feelings of homesickness in the young women. From that experience, Henry Durant was determined that thereafter the college would open on a positive note. In September 1876, he chose the text "God is Love" for the first Sunday sermon of the year, filled the chapel of College Hall with flowers, and Flower Sunday was born. It is Wellesley's oldest tradition and in recent years has become a multi-faith and multicultural celebration. The college year still opens with a theme of beauty and love, as vividly shown in this 1971 photograph of the Houghton Memorial Chapel.

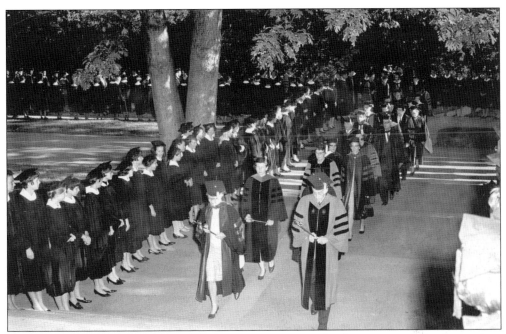

The academic year officially begins with convocation, the first opportunity for seniors to don their graduation gowns. In this 1967 photograph, faculty marshals and Wellesley president Ruth Adams lead the academic procession into the chapel, with the seniors lining the pathway. Moving away from its religious origins, for the last 20 years Wellesley has held convocation in other locations, including the Hay Outdoor Theatre and Alumnae Hall.

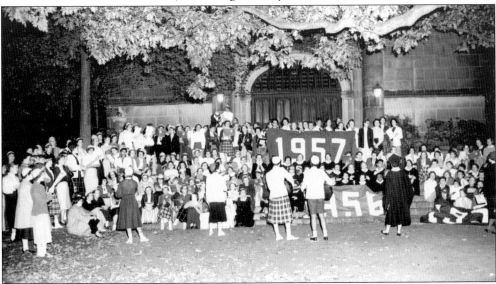

Step singing, which began as an informal after-dinner songfest, evolved into a tradition around the beginning of the 20th century. Ever since, classes have gathered on and around the chapel steps a few times a year holding their class banners and singing Wellesley songs. The most poignant of these gatherings takes place at the end of the year, when, beginning with the seniors, each class relinquishes its particular spot on the steps to the "rising" class.

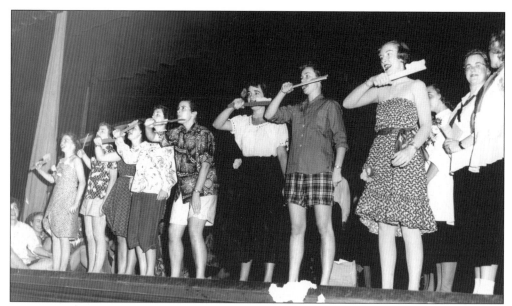

A new tradition was born in the fall of 1936, when the class of 1938 put on the first Junior Show, a successor to the old barn productions of student-written operettas. The idea was and is to unite the class and to provide a playful antidote to the seriousness of academic life. Here the class of 1952 performs their "Brush Teeth" number in the Junior Show of 1950.

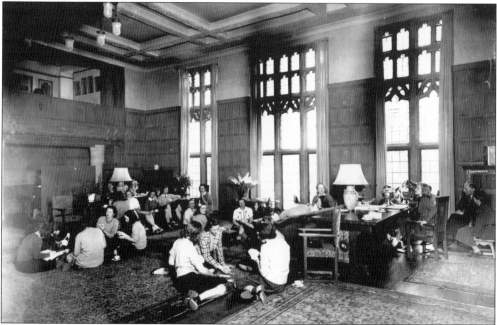

While not a tradition officially noted on the college calendar, dorm tea was nevertheless an important ritual in weekly dorm life. Rather formal in years past, the weekly dorm tea provided a time of relaxed socializing at the end of a busy day of classes. Students, gathered here in the Great Hall of Tower Court around 1941, read, study, play cards, and chat, their teacups within easy reach.

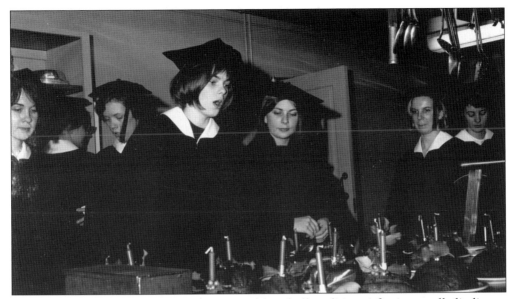

Like the weekly tea, Holiday Dinner is a residence hall tradition. A festive candle-lit dinner in December, it helps mark the end of the fall term when students are finishing papers and exams and preparing to head home for the winter break. It is another opportunity for seniors to don cap and gown, as these students have here as they observe the candle-lit plum puddings ready to be brought to the tables of the dining hall.

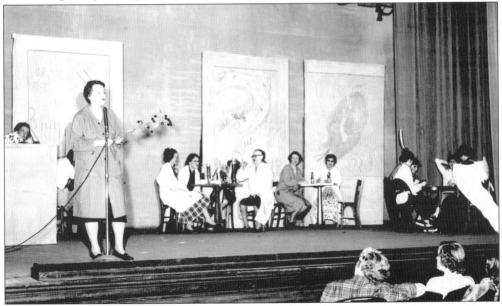

Faculty Show was a special Wellesley tradition that took place every four years from 1944 to 1960. In it, many faculty—and the president—would parody themselves in outrageous Academic Council meetings and other familiar settings. Written primarily by two professors in the English Department, these faculty shows had many highlights, including a men's ballet and Latin professor Margaret Taylor performing long scenes while standing on her head. In the 1956 show shown here, the stage set replicated the Well and its tradition murals.

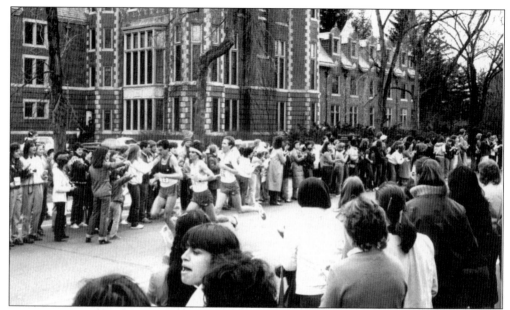

A favorite ritual of Wellesley students for decades takes place on a Monday in April—Patriots' Day and the Boston Marathon. The race course runs right past the college on Route 135 and Wellesley students, such as these outside Cazenove Hall in 1983, are known and cherished for their enthusiastic cheering at what is the halfway point of the 26-mile race. In recent years, an increasing number of Wellesley students have run the marathon themselves.

Lake Day was created by Wellesley president Nan Keohane. She envisioned a spontaneous day of canceled classes and closed offices, with the entire college community enjoying fun and food on a glorious spring day, as seen here in 1988. Unpredictable weather sometimes compromised the outdoor festivities, and Lake Day in its original conception was short-lived. Recently, students have initiated a revival of the tradition on a smaller scale.

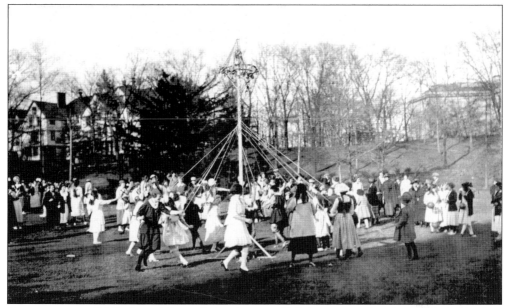

For many years, Wellesley celebrated May Day. In 1895, lamenting that they took themselves too seriously, students resolved to celebrate spring by recreating the old English May Day tradition. Although the activities of the day evolved from year to year, they often included a maypole dance, such as this one in 1919.

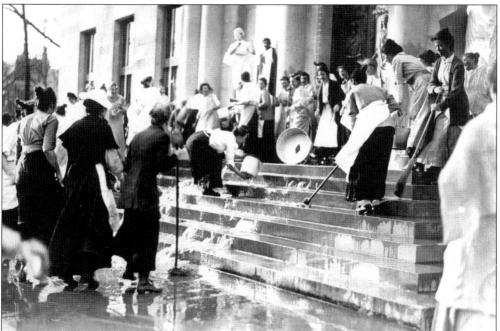

Until 1922, the first activity of May Day morning was the scrubbing of statues, particularly the *Backwoodsman* on the south porch of College Hall. This ceremony of ritual campus cleaning was later transferred to the chapel and library steps, as shown here in 1914, after the College Hall fire. Believing that the ritual had outlived its meaning, the class of 1923 voted to abandon it.

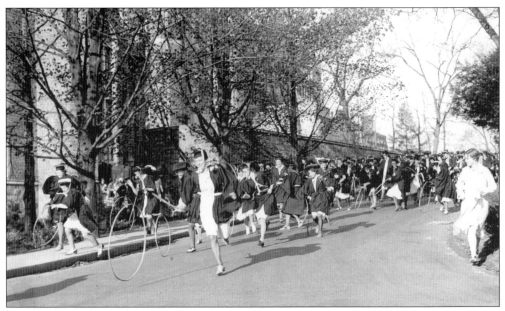

The daylong May Day celebration was quietly phased out in the 1940s; however, one aspect of the original May Day remains a favorite Wellesley tradition: hoop rolling. The route of the race has changed over the years, but for many decades hoop-rolling seniors ran from the top of Tower Court Hill to the steps of Houghton Memorial Chapel, as shown here in 1931.

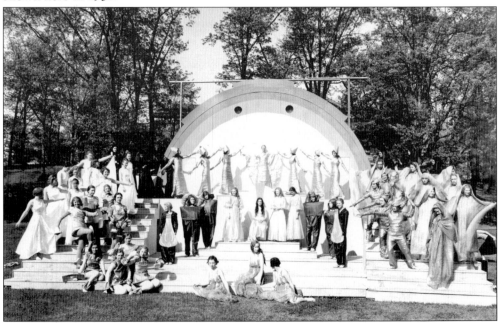

What began in 1877 with the simple planting of a class tree, initiated by Henry Durant, evolved into an elaborate pageant and day of celebration. For decades, Tree Day was the defining Wellesley tradition. A Tree Day mistress was chosen and, along with her court, presided over ceremonial dances and speeches. This elaborate set was constructed on Severance Green in 1932 for that year's production, *Pageant of Light*.

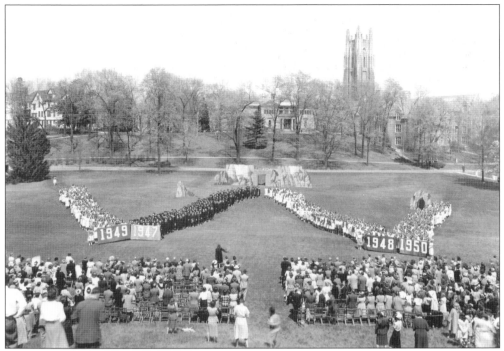

The Tree Day pageant began with the procession of classes forming the Wellesley *W*, as pictured here in 1947. Afterward all the classes would join the spectators on the hill to enjoy the performances and speeches. A sophomore Giver of the Spade would ritually present to the freshman Receiver of the Spade a simple shovel, which has been used since 1877 for the ceremonial planting of the class tree.

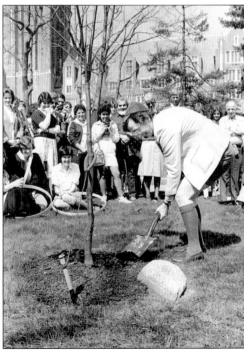

The year 1968 saw the last Tree Day pageant, a part of the tradition whose demise reflected changing student interests. The way Tree Day began, however, is the way it continues to this day—with the simple planting of a tree. Every year, the sophomore class plants a tree on campus, still using that same ceremonial spade inscribed with class numerals. Here classics professor Mary Lefkowitz (class of 1957) digs with the spade at the class of 1985's tree planting in 1983.

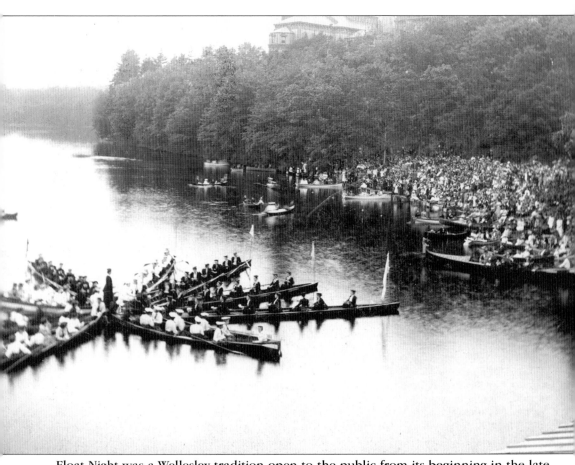

Float Night was a Wellesley tradition open to the public from its beginning in the late 19th century, unlike Tree Day which was primarily for the college community. On a late spring day at dusk, a parade of crews dressed in elaborate costumes and singing class songs would begin the event. Then, with the spectators lining the shore, the class crews in their shells would create elegant formations on Lake Waban, such as the star pictured here in 1894. By 1908, a water pageant was added to the festivities, and later students presented floating tableaux on platforms lashed to two canoes. Float Night was canceled during World War II and was a casualty of bad weather for a few years thereafter. It was revived in 1948, but after being rained out again the following year, the tradition quietly died.

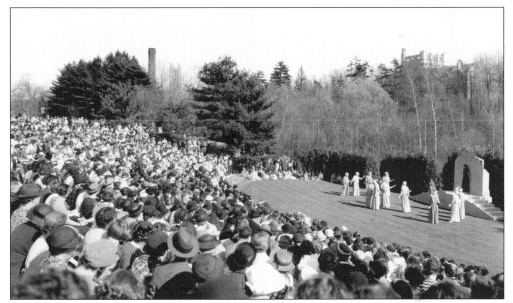

While never established officially as an annual event, classics students frequently staged a Greek play at the end of the academic year. The first production took place in 1934, in original language and with costumes and sets replicating those of ancient Greece. Here in 1936, *Prometheus Bound* was performed in the newly opened Hay Outdoor Theatre, adjacent to Alumnae Hall.

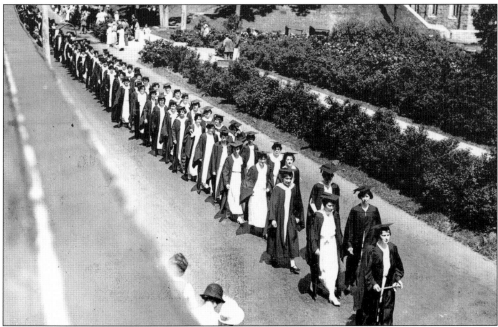

Beginning in 1879, Wellesley has annually celebrated commencement in May or June with great pomp and joy. These students in the 1920s are processing to the chapel, where commencement took place for many years. (The picture was taken from the top of the Hen Coop, the temporary administration building built on the chapel lawn after the College Hall fire.)

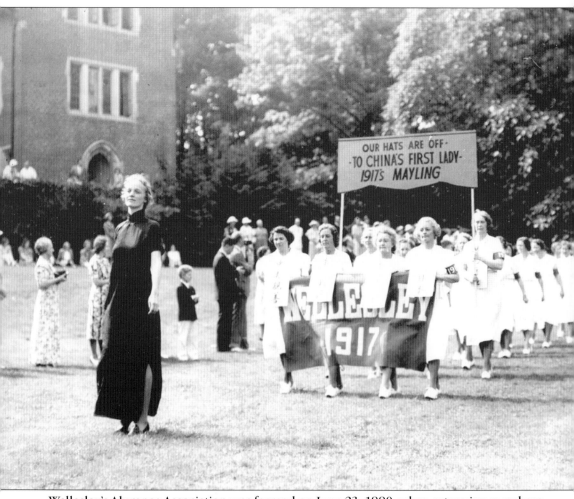

Wellesley's Alumnae Association was formed on June 23, 1880, when returning members of the class of 1879 joined the new graduates of 1880 in electing officers and adopting a constitution. A tradition dear to the great majority of Wellesley's alumnae is reunion. For many decades, reunion took place on the same weekend as commencement, but eventually it was decided to hold reunion one week later so as not to detract from the graduates and their accomplishments. In addition to revivals of Wellesley traditions such as step singing and a float performance, the highlight of reunion weekend is the Alumnae Parade, in which the processing classes dress all in white with an insignia item for each class, perhaps a hat or a bag, in their class color. These insignia evolved from the time when classes would actually dress in elaborate costumes for the parade. In 1942, the class of 1917 marched proudly in their 25th reunion parade without fanciful costumes, proclaiming with their signs that they were sending reunion money traditionally spent on such outfits to China in support of the work of their classmate Mayling Soong, later Madame Chiang Kai-shek.

Six

CAMPUS PLACES

On a visit to Wellesley College, the Irish poet William Butler Yeats remarked to Pauline Durant, "You have chosen a place eternally beautiful." And indeed, throughout the history of the college, that adjective has been used often to describe the essence of Wellesley's extraordinary campus. The charm and elegance of all that was inside College Hall was equaled by the exquisite loveliness of its lakeside landscape. As time passed and the college grew, new buildings graced that landscape, each making a unique contribution to Wellesley's "park," as the campus was called until the early 1900s.

Initially, there was no systematic "campus plan." The variety of architecture and building sites during the first 30 years attests to this. By the beginning of the 20th century, however, Wellesley president Caroline Hazard and her trustees realized that they needed to think about the big picture. In 1902, President Hazard invited landscape designer Frederick Law Olmsted Jr., the son of America's preeminent landscape architect, to help in planning the direction for campus growth. His response, known as the "Olmsted letter," emphasized the uniqueness of "a landscape not merely beautiful, but with a marked individual character not represented so far as I know on the grounds of any other college in the country." The ideas in Olmsted's letter began a deliberative process of planning and building and reenvisioning the campus that continues to this day. The most recent iteration of this ongoing effort is the 1998 Master Plan, which called for a renewal of the landscape and a management plan for the future. One of the first steps in implementing the Master Plan's recommendations has been the reclamation of Alumnae Valley.

Most of the buildings pictured in this chapter still exist; many of the earlier ones, long gone, have appeared elsewhere in this book. Wellesley's 500-acre campus is so much more than its buildings, however, and this chapter concludes with photographs of some of the most treasured "campus places." The beauty Yeats found so remarkable 100 years ago still takes one's breath away.

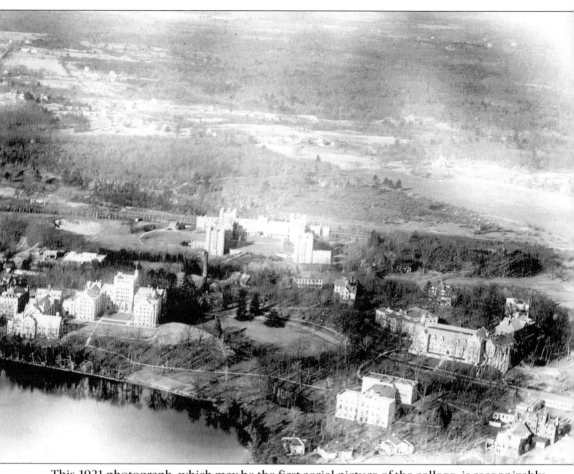

This 1921 photograph, which may be the first aerial picture of the college, is recognizably the Wellesley campus. Yet the photograph is also a time capsule, combining the familiar with the unfamiliar to those who know Wellesley today. Tower Court and Claflin are here, but the photograph predates Severance. Next to Claflin on the extreme left is the kitchen wing remnant of College Hall, used for decades in various capacities. Just below the Hazard Quad in the center are the Chemistry Building and Norumbega Cottage. The Academic Quad is virtually unrecognizable to the modern eye: Founders is there, but circling clockwise are Farnsworth Art Building, Wood Cottage, Freeman Cottage, and Wilder Hall—all now history. The H-shaped structure at the bottom is the original Clapp Library before the 1956 and 1974 additions. On the far right is the original TZE society house, torn down and rebuilt in 1929 near the other society houses visible here just below the library. The odd structure above Billings Hall at the lower right is the Hen Coop, the classroom and administration building hastily built after the 1914 College Hall fire.

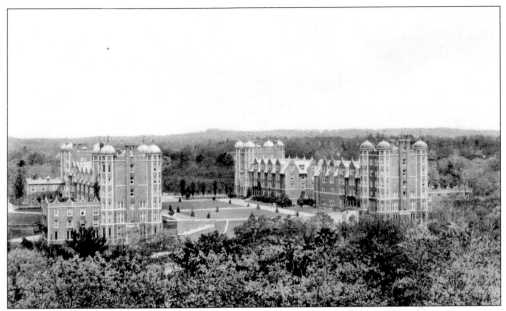

The Hazard Quadrangle is made up of four dorms built in the first decade of the 20th century during the presidency of Caroline Hazard. From left to right in this photograph are Cazenove (1905), Beebe (1908), Pomeroy (1904), and Shafer (1909). Strikingly absent is the link between Cazenove and Pomeroy, which was added in 1920, effectively enclosing the quad from the main thoroughfare of Route 135.

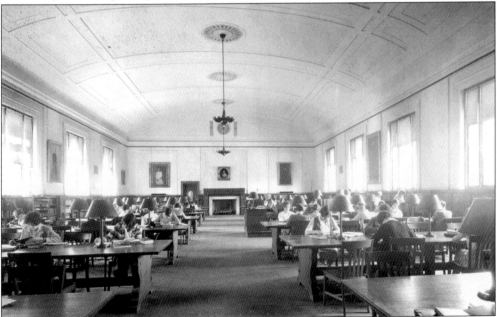

In 1909, a new library was constructed near Lake Waban to relieve the overcrowding in the library in College Hall. An addition was added on to the back seven years later, creating the H-shaped building prominent in the 1921 aerial photograph. Portraits of Wellesley's presidents are displayed in the main reading room of the library, as shown here around 1930. They grace the walls of the room to this day.

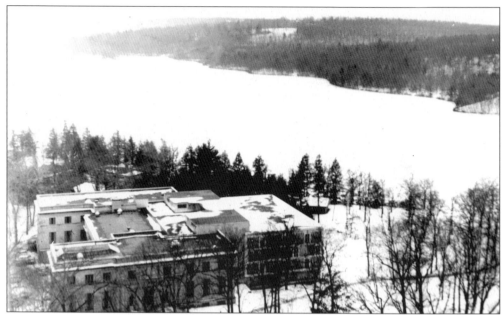

The library doubled in size in 1956 with the addition on the western side, as seen in this photograph taken from Galen Stone Tower. In a second expansion completed in 1974, new space was added to both the eastern and western sides of the building. At that time, the library was named in honor of Margaret Clapp, Wellesley's eighth president, who had recently passed away.

When students returned to campus on April 7, 1914, just three weeks after the College Hall fire, they were greeted by this structure built on the chapel lawn in 15 days at a cost of $32,800. Nicknamed the Hen Coop, and intended to be temporary, it provided classroom and administrative space for 17 years.

On March 17, 1931, the anniversary of the College Hall fire, Wellesley president Ellen Pendleton blew a trumpet at 7:45 in the morning and led an "attack" on the Hen Coop. Students and faculty reveled in this authorized vandalism, which continued into the night with the bonfire seen here. Between the reveille and the bonfire, a special chapel service was held to dedicate the recently completed Green Hall.

The Hen Coop was not the only temporary structure built after the fire. The Zoology Department found a new home in this building, built during the summer of 1914, and nicknamed "the Ark." Simpson Cottage, the college infirmary, is seen in the background on the left, and an early society house is on the right. The Ark was demolished in 1931 when the Zoology Department joined the Botany Department in Sage Hall.

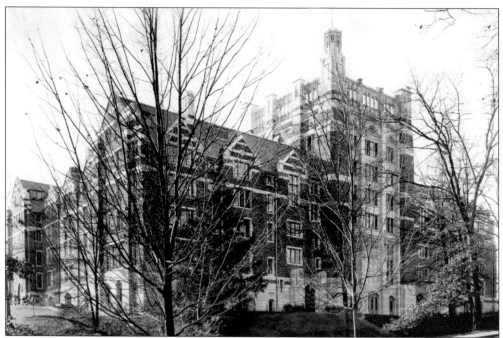

While the loss of classroom and office space in the fire was significant, it also left 216 students and faculty homeless. It was quickly decided that the hill once occupied by College Hall would be devoted solely to dormitory space. On September 25, 1915, only 15 months after the fire, Tower Court, the first of these dormitory buildings, was opened to 194 students and 12 faculty members.

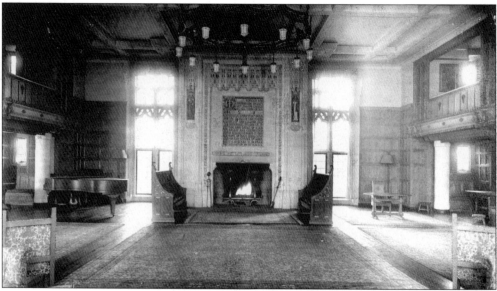

The beloved Center of College Hall could never be duplicated; instead, Great Hall was built in Tower Court, connecting the east and west wings. It is formally furnished and ornately decorated with woodcarvings and various college seals in the stained glass windows. In the center of this picture, above the fireplace, is a memorial plaque honoring Ellen Stebbins James, the primary donor of the building.

Eventually, the hill held two other dormitories: Claflin, built to the west of Tower Court in 1917, and Severance, built to the east in 1927. On the left is the large oak tree visible in early College Hall photographs and still standing today. Stacks of chairs near the bottom of Severance Hill suggest that this photograph was taken at the time of an important event on the green, perhaps Tree Day.

The liberal arts building named Founders opened in 1919. While paying tribute to the Durants, its designation also honored their staunch wish never to have their names inscribed on the campus, a wish upheld to this day. In order to receive permission to build during the war years, Wellesley invited the appropriate officials to a meeting in the Hen Coop at the precise moment of chaos between class periods in that cramped building. Not surprisingly, permission was granted.

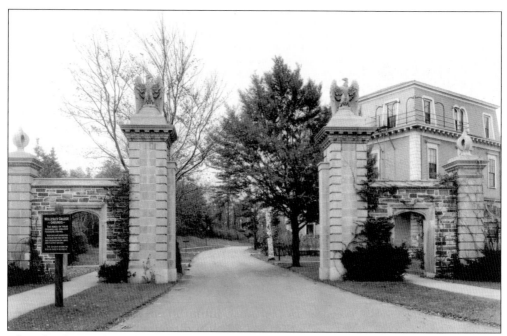

After the fire and World War I, Wellesley began to look outward, to seek connections with the town and the wider world. Symbolizing this new perspective, in 1922, a new main entrance, with gates given by the class of 1916, was constructed near the town of Wellesley on Central Street next to Fiske House (on the right). This served as the main entrance to the college until the 1961 redesign of the campus roads when this entry road became a pedestrian walkway.

In 1908, students began raising money for a "student building," a wish that took a backseat after the fire to more pressing needs. The building finally opened on December 5, 1923, with the Boston Symphony Orchestra performing a dedication concert. Originally named the Student-Alumnae Building, and later Alumnae Hall, it houses a 1,500-seat auditorium, a ballroom, office space, and, since 1992, the Ruth Nagel Jones black-box theater.

On the left is Mary Hemenway Hall, built when the Boston Normal School of Gymnastics was absorbed by Wellesley in 1909. On the right is the Recreation Building, completed in 1938, which provided additional gymnasium space as well as a swimming pool. Hemenway Hall was demolished when the Sports Center was built in 1985, and the Recreation Building was integrated into the new construction.

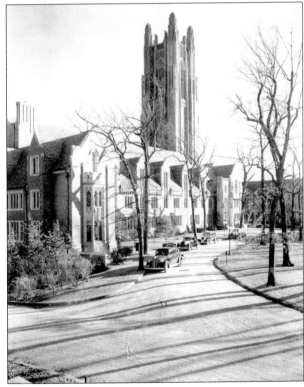

Green Hall, the main administration building, was completed in 1931 and dedicated on the day the Hen Coop was torn down. It was the second building, after Founders, in what was to become the academic center of the campus. Rising above it is Galen Stone Tower, visible from all parts of campus.

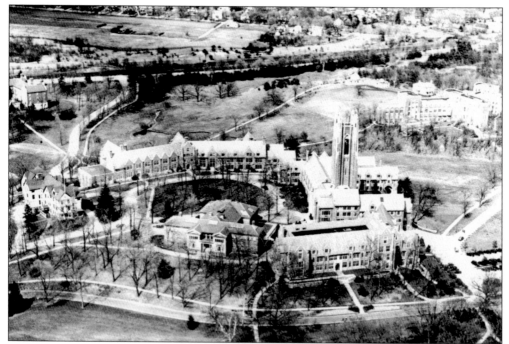

In 1935, Pendleton Hall, named after Wellesley's sixth president at the students' request, was completed and became a home for the Psychology, Chemistry, and Physics Departments. This late-1940s view of the Academic Quad shows Founders, Green, and Pendleton Halls, as well as Farnsworth Art Building (in the center) and Norumbega Cottage (on the left).

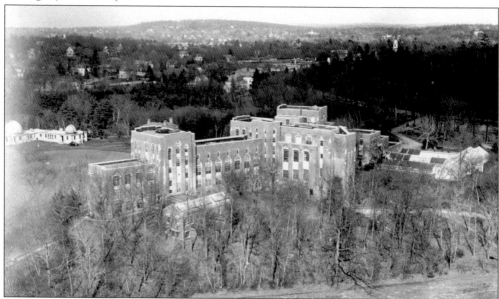

Sage Hall was planned and completed in two stages. The wing for botany, the science department hardest hit in the fire, was opened in 1927, and the zoology wing followed in 1931. The main entrance originally faced the observatory, seen here on the left. The greenhouses, on the right, were constructed in 1922.

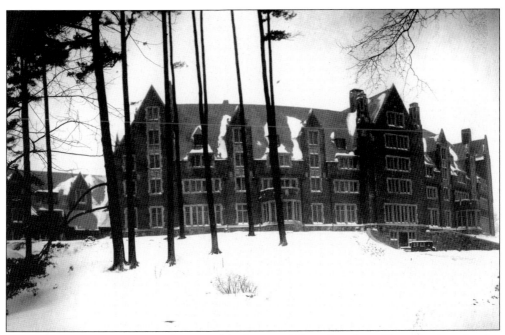

The original Stone Hall was destroyed by fire in 1927 and replaced by twin dormitories built on the same hill. The right half remained Stone Hall, and the left was named for Olive Davis (class of 1886), a long-serving director of residence. The car in this photograph is parked at what was the food service entrance. With the 1964 renovation and addition of a dining hall, this area became the main entrance for Stone-Davis.

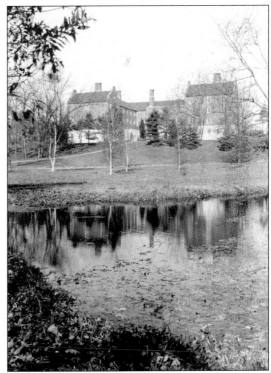

Munger Hall opened in 1933 as a cooperative house; students living here did some of the domestic work in the dormitory in exchange for a reduction of fees. While this policy did segregate students on financial aid, Munger Hall proved to be an active, social dormitory much in demand by students. Financial-need-based houses were abolished in 1952.

This prefabricated building was purchased from the U.S. Navy and moved to campus in 1947. Called Navy House, it housed 50 freshmen (as first-year students were then called) whom the college felt it could absorb without needing to increase classroom space. In the post–World War II years, Wellesley sought ways to increase income and stabilize expenses. Finding space to house students who brought in that additional income took some careful planning.

With the plans for additional dormitory space in place by the mid-1950s, the college sought to fulfill other needs, such as a gathering space for faculty, trustees, and alumnae. The Wellesley College Club opened in 1963 on the land formerly occupied by Navy House. It provided a dining room, conference rooms, and guest rooms, as well as beautiful views of Lake Waban.

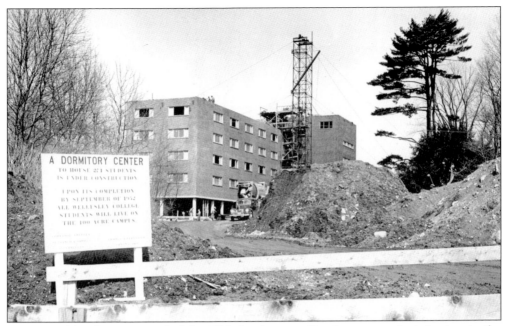

A principal fund-raising goal of the 75th Anniversary Fund was new dormitories. As the sign in this picture reads, "A dormitory center to house 271 students is under construction. Upon its completion by September of 1952, all Wellesley students will live on the 400 acre campus." In the center of the photograph is Freeman Hall, under construction.

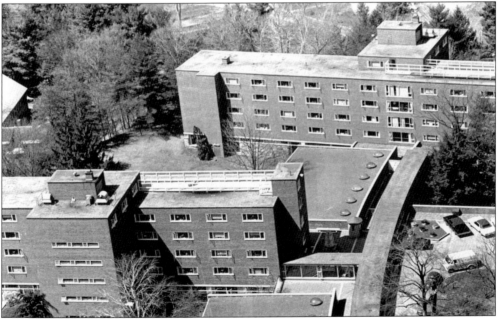

The new residential complex was referred to as "the New Dorms," and over 50 years later, the name remains. Bates, in the foreground, was named for Katharine Lee Bates, and Freeman, behind it, for Alice Freeman Palmer. They were completed in 1952; the third dormitory in the complex, McAfee, named for Wellesley's seventh president, was built in 1961.

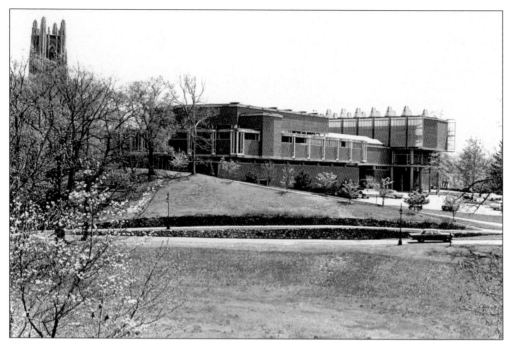

The Jewett Arts Center opened in 1958. It completed the Academic Quad and provided wonderful new space for the study of art, music, and theater. The Music and Art Departments had separate libraries and classrooms, the Art Museum had new exhibit halls, and an auditorium provided an elegant performance space.

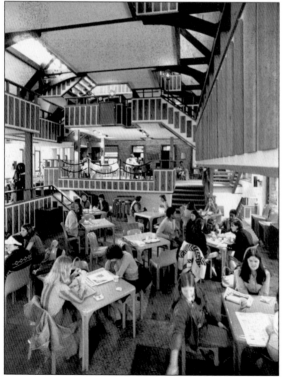

After the Music Department relocated to Jewett, Music Hall was made available to the students. Over the years, student organizations had occupied makeshift homes scattered across the campus, but now an entire building was devoted to the activities of student life. By 1970, the original Billings Hall was transformed into this multilevel social and student-activity space, and the two buildings together were named the Schneider College Center.

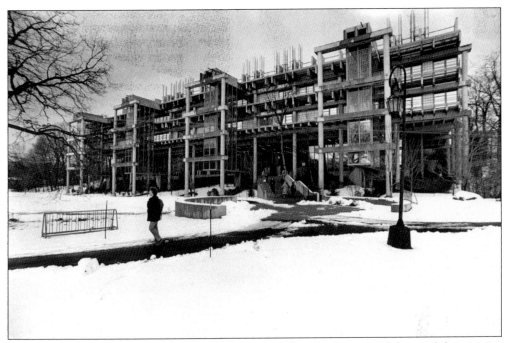

The goal of housing all the sciences in one building with state-of-the-art laboratories and facilities was achieved in 1977 when a huge addition was made to Sage Hall. The modern structure, uniquely combining the old and the new, was named, simply, the Science Center.

In its early years, Wellesley had been a pioneer in physical education for women. By the Title IX years, however, it was clear that Wellesley's athletic facilities needed to be expanded. In 1985, a new sports center, incorporating the old Recreation Building and including a new field house and pool wing, opened to much fanfare. The building was named the Keohane Sports Center in honor of Nan Keohane when she left Wellesley in 1993.

Wellesley's extraordinary art collection outgrew the exhibition space in Jewett Arts Center rather quickly. After years of planning, the Davis Museum and Cultural Center was built, adjacent to Jewett, in 1993. The four-story museum, which houses the college's extensive collections, also has a small theater and café.

The Lulu Chow Wang Campus Center opened in the fall of 2005. This unique building, with its stunning views of Lake Waban and the new Alumnae Valley, contains meeting spaces for student organizations and campus groups, eating facilities, the college bookstore, and the post office. It was designed to bring together the entire Wellesley community of students, faculty, staff, and alumnae in a building that reflects the diversity and modernity of the college today, and it is already serving this purpose beautifully.

The 500 acres of Wellesley's campus hold much more than the buildings pictured so far in this chapter. From the beginning, members of the Wellesley community have sought peace and tranquility throughout the grounds. Some of these beautiful spaces have been lost or transformed over time; others remain nearly unchanged, evoking feelings today shared with the women who studied and lived here more than 100 years ago. A prime example is shown in this picture. The path by the lake below College Hall proved so popular that Henry Durant had rustic bench-rimmed platforms built so that those out for a walk would have a place to rest and reflect. They became a favorite place for students and visitors and came to be called "spoonholders." Repaired and rebuilt over the years, they are a constant source of delight, as these students from 1891 would agree.

The path to Tupelo Point is evocatively captured in this 1929 photograph. The point, which juts out into Lake Waban, was named for the tupelo trees growing there. A sign in the college boathouse declares the legend of Tupelo Point: "If, on the occasion of a couple's third visit to this sacred spot, the girl is not asked for her hand, she must fling the woeful suitor into the depths of Lake Waban."

Hidden among the trees on the path down to Tupelo Point is this beautiful spot, a memorial to Lucy Annabel Plympton (class of 1899) given by her friends and family. The inscription on the stone bench overlooking the lake describes Plympton as "lover of tree and wind and water, of bird and flower and friendly beast."

The lamps that light the paths and walkways throughout the campus, like this one near the stone bridge leading to the President's House, date back to the 1920s—a vivid and distinctive silhouette familiar to students and alumnae around the world. The stone bridge was given by two of Ellen Pendleton's classmates in honor of their mothers in 1927. It greatly shortened the time it took the president to get to morning chapel.

The swamp at the end of the brook winding through the Alexandra Botanical Gardens was dredged decades ago, creating a pond. The microorganisms that eventually flourished here, once routinely researched by zoology classes, led to its name Paramecium Pond. To this day, it is a site for ecological research, a spot for frog-watching, an ice-skating rink during the coldest winters, and a place of timeless quiet and loveliness.

The walk around Lake Waban changed dramatically in 2002 with the environmental cleanup of the Paintshop Pond area around the restoration of the natural wetlands along the lake's western cove. The project included new athletic fields and the wonderful boardwalk seen here, crossing the wetlands that serve as a living laboratory for students.

One of Wellesley's recent visionary decisions about the preservation of its beautiful campus has been the reclamation of the land between the power plant and the lake, an area that had long been used as a parking lot. The 10-acre site has been transformed into Alumnae Valley, a parkland of drumlins, marshes, and vistas in all directions to delight all who pass through for generations to come.

Seven

WELLESLEY'S MOTTO
AND MISSION

Non Ministrari sed Ministrare—"Not to be ministered unto, but to minister." The motto Henry and Pauline Durant chose for their new college is a reflection of their time. Middle- and upper-class American women in the late 19th century were often cared for by and dependent upon men. The Durants hoped to inspire the young women at Wellesley to rise above those constraints and become women who would claim a place in the world where in service to others they might attain a sense of fulfillment and power.

The motto, in the words of Wellesley president Nan Keohane in 1981, "remains accurate today in depicting the great range and spectrum of action by Wellesley women." Inspired by the passionate esteem in which the Wellesley community holds the motto, students absorb and begin to act on it during their undergraduate years, as depicted in the photographs in this chapter. This commitment to service inspires and sustains the lives of Wellesley's alumnae, who are, in the words of Helen Bullard Rydell (class of 1926), "the women who take what Wellesley has offered and use it to give the world some of what she has given them." Indeed, in 1989, the college adopted a mission statement that complements and amplifies the significance of the motto: "Wellesley College provides an excellent liberal arts education for women who will make a difference in the world."

With all the growth and change that has transformed Wellesley since the Durants' time, the motto endures. Writing in 1923, Mary Caswell, presidential secretary for 36 years, puts the question for her generation, and for ours: "What would Mr. Durant say? . . . I think that if he could look upon us [today], he would be more than likely to say something like this, . . . 'I am very glad to see your material advance. It is most gratifying. . . . But there are some things I must know. Tell me, is the college motto, "Not to be ministered unto but to minister," still an active force? Do trustees and officers and teachers still bear in mind that ideal of true education, the highest learning in harmony with the noblest soul?'"

The answer is, of course, a resounding yes.

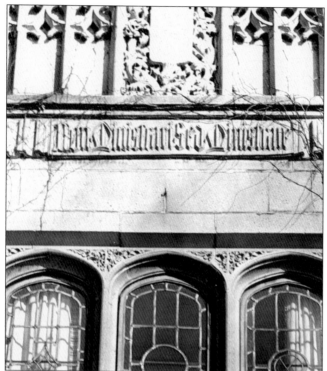

Wellesley's motto *Non Ministrari sed Ministrare* has adorned buildings and rooms throughout the campus, beginning with the chapel in College Hall. Public inscription of the motto continued over time—for example, above the fireplace in Great Hall of Tower Court and here above the windows of the arch connecting Tower Court and Claflin.

An early student expression of the motto was community service organized through the Christian Association. At the annual Silver Bay Conference in upstate New York, Wellesley's Christian Association delegates (such as these students in 1916) met with like-minded delegates from other schools.

By the 1890s, suffrage had become a topic of lively conversation and debate on the Wellesley campus. In 1915, Wellesley students marched in this suffrage parade in Philadelphia. Later this photograph was used in a *New York Times* International Ladies Garment Workers Union advertisement that declared that these "radical" college students were models of women who marched for their rights and won them.

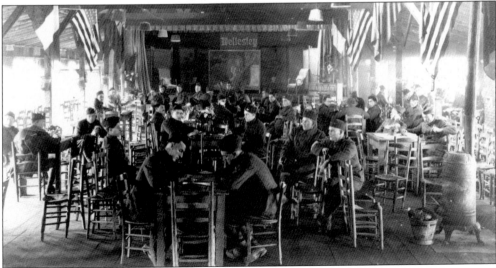

When America entered World War I in 1917, Wellesley president Ellen Pendleton joined other college presidents in pledging support for the war effort to Woodrow Wilson. One initiative raised money for Wellesley Relief Units, which were made up almost entirely of Wellesley graduates who served in Europe and the Near East, taking part in relief, refugee, and medical support efforts. Work with convalescent soldiers included a college-funded canteen known as the "Wellesley Hut," (note the banner in the background) at a base hospital in France.

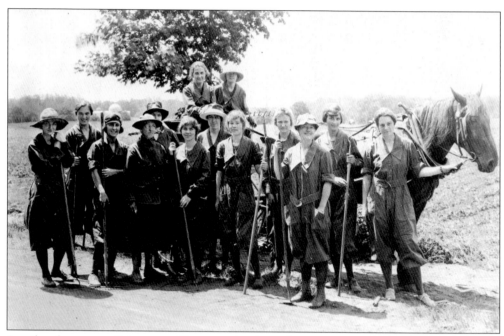

Another key part of the war effort was food production on Wellesley's land. Here the self-proclaimed "farmerettes" pose with botany professor Margaret Ferguson, fourth from left, who supervised the vegetable gardens.

Wellesley students have long taken part in local service initiatives. For many years, for example, the Christian Association collected dolls for sick children in Boston-area hospitals. Students in 1921 pose here with the dolls before delivering them to their new homes.

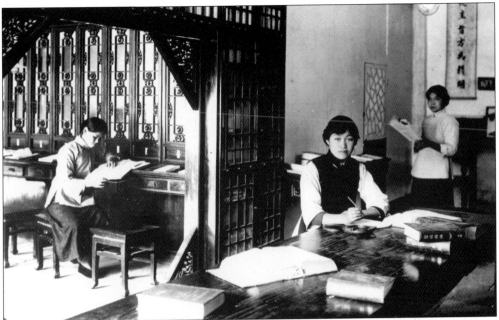

In 1908, Wellesley students sent a donation to the Yenching College for Women in Peking, China, launching a relationship that has continued to this day. In 1919, Wellesley formally adopted Yenching as its sister school. In this undated photograph, Yenching students are seen inside their library, a former Buddhist shrine. Wellesley president Ellen Pendleton visited the school on a trip to China in 1919.

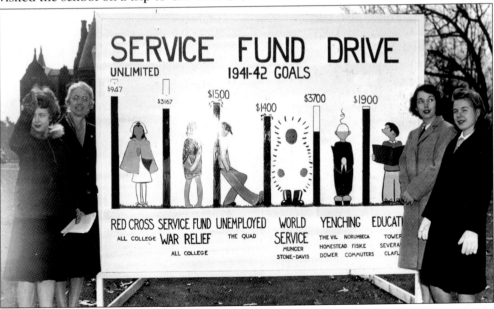

For many decades, the Service Fund was the central charitable fund-raising organization on campus. It allocated money to a number of worthy causes, including Yenching. In this photograph, botany professor and later dean of residence Ruth Lindsay (class of 1915, second from left) and students pose next to the board showing the goals of the 1942 Service Fund Drive.

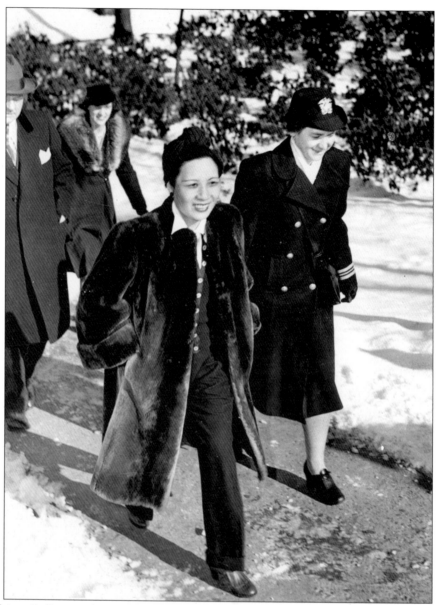

Yenching College is by no means Wellesley's only connection with China. Mayling Soong, the daughter of an influential and prosperous Chinese businessman, was sent to the United States for her education, culminating in her graduation from Wellesley in 1917. A decade later, she married Chiang Kai-shek and played an increasingly important role in Chinese political life as the wife of the leader of the Guomindang (Nationalist) party. During World War II, she served as an intermediary between her husband and the American military forces stationed in China. Ever supportive of Madame Chiang's work in her homeland, Wellesley welcomed her back with open arms during this 1943 visit. Here she tours the campus with Wellesley president Mildred McAfee before going on to Washington, D.C., to meet with Franklin Roosevelt. Madame Chiang returned to the United States after her husband's death in 1975 and lived here until she died in 2003 at the age of 105.

Another World War II campus activity for war relief was the United National Clothing Collection Drive. Students here in 1944 helped pack over 3,000 pounds of clothing collected at the college.

Wellesley offered space on campus to the U.S. Navy Supply Corps in the fall of 1943. While students doubled up in other dormitories, the men lived and attended training classes in Pomeroy and Cazenove Halls, and the Alumnae Hall ballroom became their galley and mess hall. Four groups of service men stayed for an 18-week course, delighting many students with their temporarily coed campus.

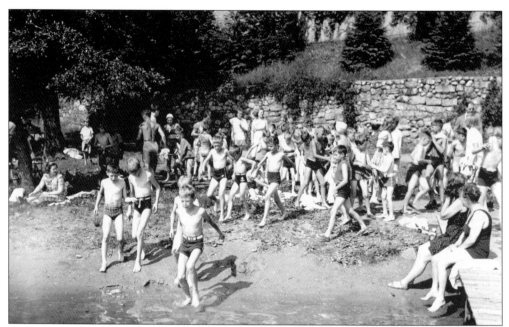

In the summer of 1941, more than 100 British children, escaping the devastation of war in their country, took up temporary residence at Wellesley. A number of faculty and students stayed on campus for the summer to help to take care of these youngsters, seen here enjoying Lake Waban.

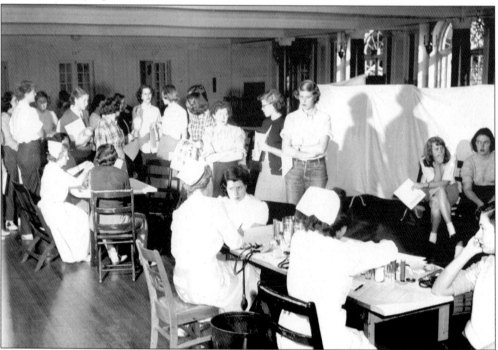

Wellesley's service initiatives have consistently supported the Red Cross. Here students line up to donate blood at the Red Cross Bloodmobile in 1950. Today the college holds several blood drives each year.

In 1957, ten Hungarian refugees—fleeing the Communist clampdown after the failed revolution—came to Wellesley. They came to learn English and to continue their education, and the entire college community embraced them with support services that ranged from English tutoring to raising money for their living expenses. Three Hungarian-speaking Wellesley students, shown here preparing rooms for the refugees, served as their first translators.

Wellesley has long supported local community organizations in the Greater Boston area. An urban service program was launched in the fall of 1970, in East Boston, under the supervision of Wellesley sociology professor Stephen London. Hundreds of Wellesley students volunteered in that urban neighborhood over the next few years, running teen programs, helping coordinate social services for the elderly, and working with the children of immigrant families, as seen in this photograph.

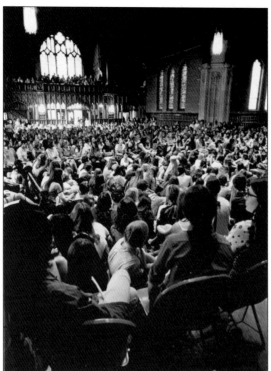

In the late 20th century, many students came to interpret the Wellesley motto as a call to social and political activism. In May 1970, a community-wide meeting in the chapel debated the possibility of Wellesley's joining other colleges around the country in a strike proposed by the National Student Strike Organization, whose demands included an end to the war in Vietnam.

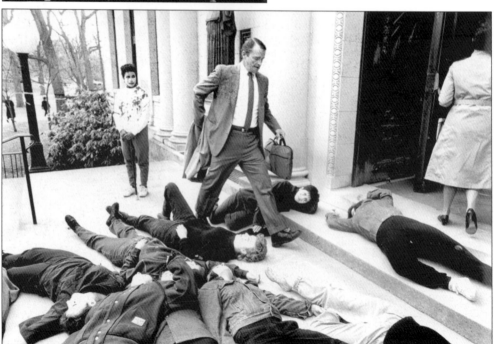

In the mid-1980s, with the support of Academic and Administrative Councils, students called for the total divestment of Wellesley funds from companies doing business in South Africa. Here, in 1986, trustees attending their quarterly meeting had to step over students staging a "die-in" on the Clapp Library steps as a part of their protest.

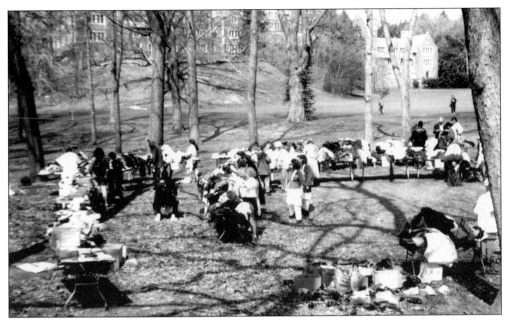

Starting in the mid-1980s, an important focus of community service was support of Rosie's Place, a women's shelter in Boston that opened in 1974. For a number of years, students raised money for this cause through the annual Rummage for Rosie's Sale that took place during Spring Weekend, as seen here in 1993. This sale of donated clothing and other items raised several thousand dollars each year. Today Rosie's Place is a beneficiary of Wellesley's annual charitable giving campaign.

A recent manifestation of Wellesley's motto is the annual Day to Make a Difference. Initiated by the Alumnae Association in 2000 as part of Wellesley's 125th anniversary celebration, students and alumnae around the world volunteer a day of service in activities ranging from working in a food bank (as students are doing here) to helping organize a breast cancer awareness walk.

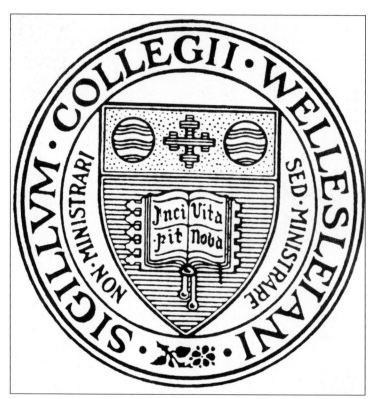

Wellesley's motto is a part of the official college seal, the first version of which was adopted by the college in 1882. In 1917, a new version embodied a coat of arms, as shown here. The Latin words on the open book, *Incipit vita nova* ("Here beginneth new life") from Dante's *La Vita Nuova*, were used by Henry Durant as the theme of his address to the college in its first year on the "Spirit of Wellesley."

The spirit of Wellesley is also symbolized in the official Keys to the College, formally presented to each president at her inauguration, beginning with Caroline Hazard in 1899. On the left is the Key of a Dormitory, with a hearth representing the warmth of domestic life at a residential college. In the center is the Key of the Library, with an owl and an open book representing intellectual life. On the right is the Key of the Chapel, with a stylized cross representing spiritual life.

Complementing its motto *Non Ministrari sed Ministrare*, the college adopted a mission statement in 1989: "Wellesley College provides an excellent liberal arts education for women who will make a difference in the world." In 2000, colorful banners were hung from lampposts around the campus. The banners are inscribed with words from the mission statement and the names of alumnae whose achievements have "made a difference in the world." Many of them have been recognized with the Alumnae Achievement Award, Wellesley's highest honor. Inspiring and evocative as the banners are, there are not enough lampposts on the college grounds to proclaim the accomplishments and triumphs of the thousands of women who have graduated from Wellesley over the past 130 years or to account for the college's influence in the world. Wellesley lives beyond the campus in the hearts, minds, and deeds of its graduates.

ACROSS AMERICA, PEOPLE ARE DISCOVERING
SOMETHING WONDERFUL. *THEIR HERITAGE.*

Arcadia Publishing is the leading local history publisher in the United States. With more than 3,000 titles in print and hundreds of new titles released every year, Arcadia has extensive specialized experience chronicling the history of communities and celebrating America's hidden stories, bringing to life the people, places, and events from the past. To discover the history of other communities across the nation, please visit:

www.arcadiapublishing.com

Customized search tools allow you to find regional history books about the town where you grew up, the cities where your friends and family live, the town where your parents met, or even that retirement spot you've been dreaming about.